weekend wraps

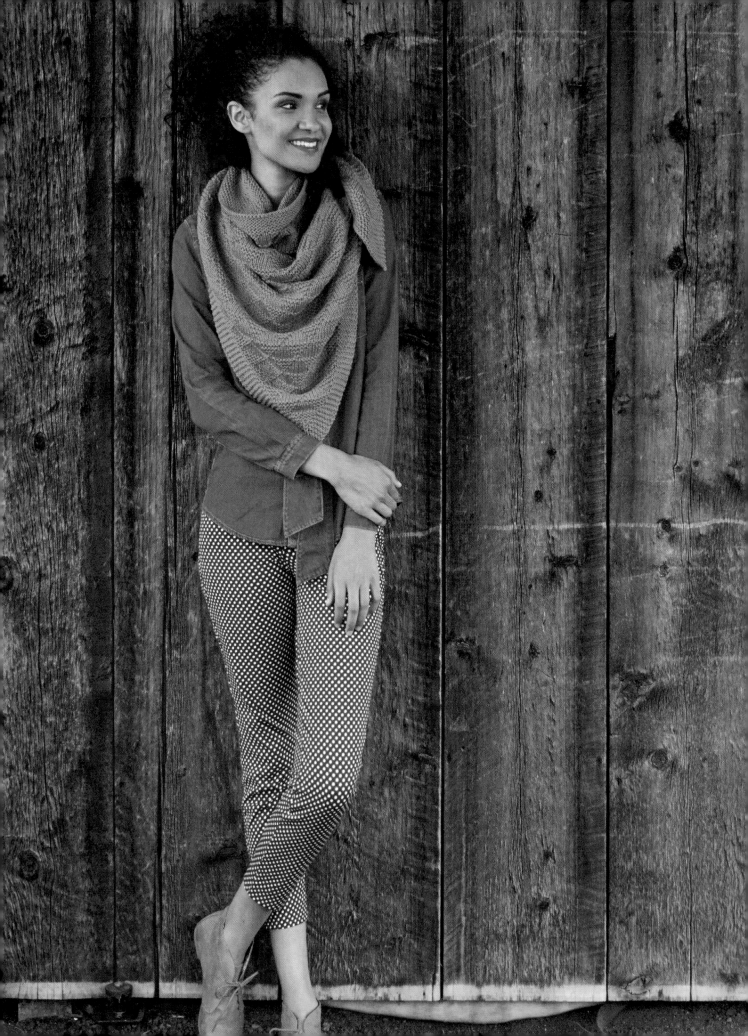

weekend wraps

18 quick knit cowls, scarves & shawls

Cecily Glowik MacDonald and Melissa LaBarre

INTERWEAVE.
interweave.com

Contents

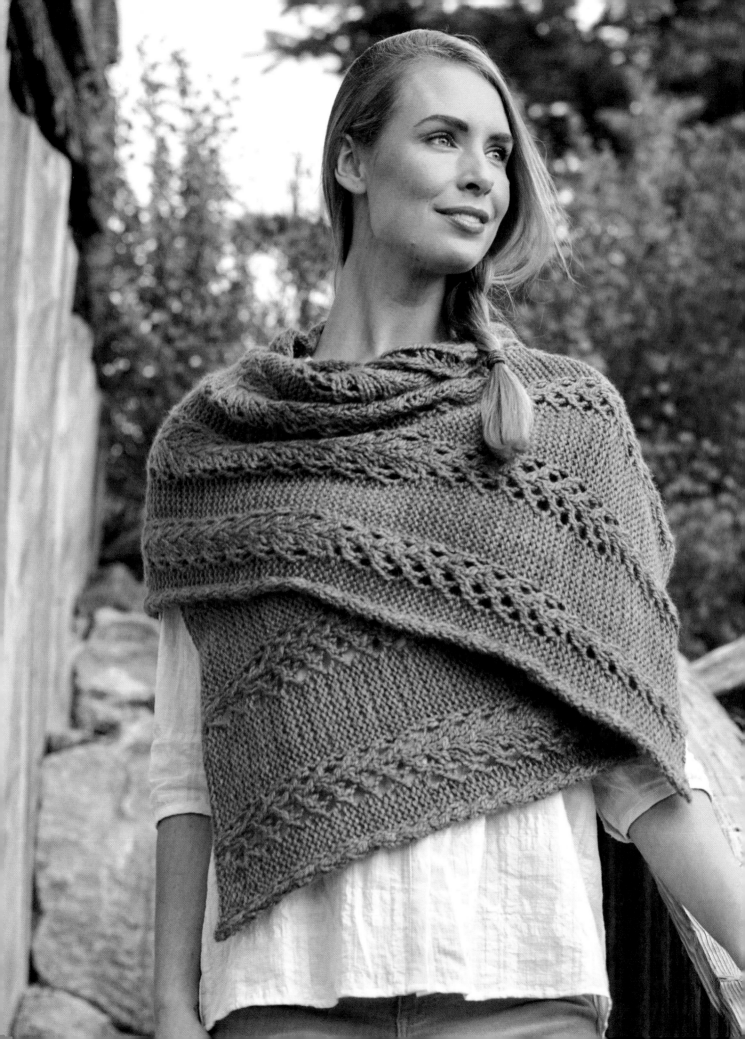

Introduction

This, our third book with Interweave, began with some questions: What would you want to make over a weekend, if you could really just spend a few days relaxing and knitting? What would you want to wear on an autumn weekend away? What's your ideal accessory on a brisk fall walk? What would you wrap yourself in while warming up in front of the fire? We covered hats last time. What about something bigger?

We approached designers who we know also love to ponder these questions, and we gave them one other guideline: Use only worsted or heavier yarns, so that someone might even finish their project in a short, or long, weekend. We were overwhelmed by their enthusiastic response and the designs they came up with. The result is a collection of designs that we absolutely love and are so excited about.

There are cowls, shawls, scarves, wraps, and shrugs for knitters of all skill levels included in this volume. We hope you'll find several projects that have you grabbing your needles and casting on!

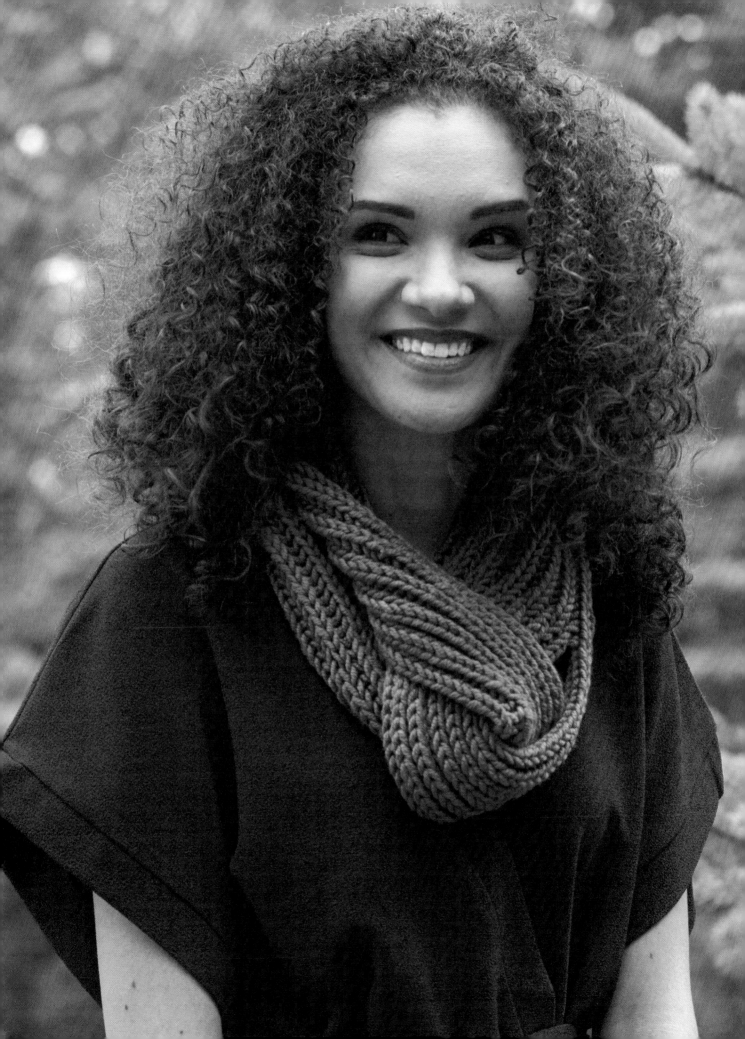

A Few Quick Cowls

Cowls are great everyday projects because of their portability. Keep one in your bag or tote so you can easily sneak in a row or two on your lunch break or while waiting for an appointment. They also make great quick gifts, and these lovely loops worked in worsted-weight and bulky yarns are sure to knit up in no time.

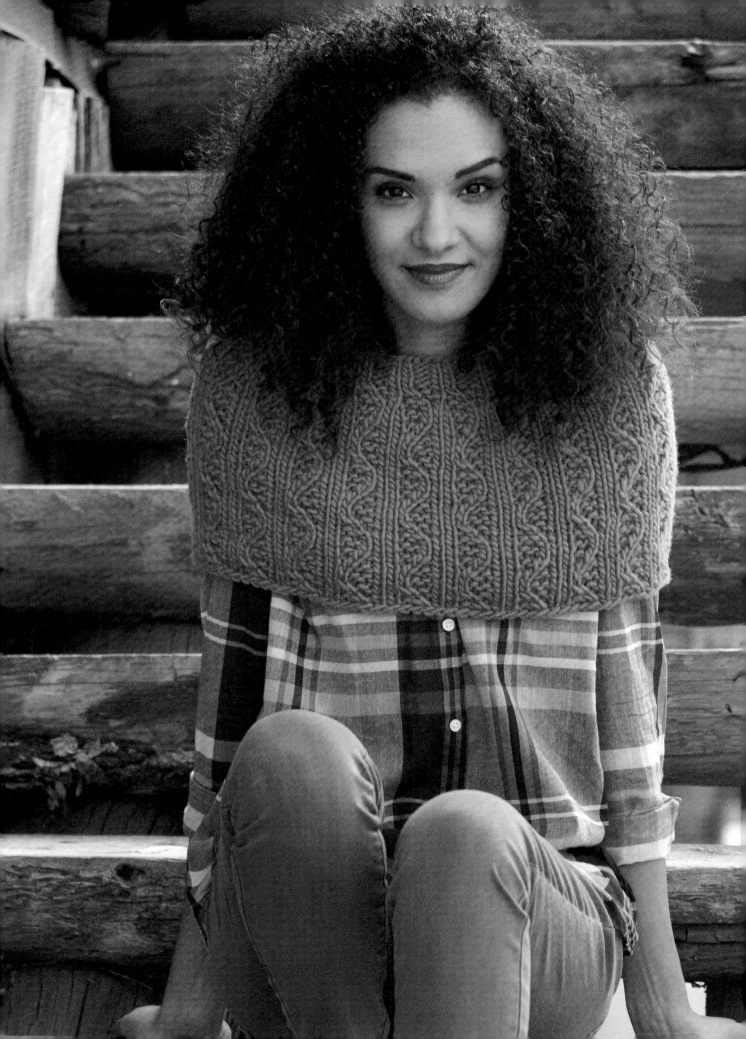

Designed by Carrie Bostick Hoge

Little Waves Cowl

This little cowl uses a sweet stitch and a bulky yarn to make a quick cool-weather accessory. It features shaping that will help keep the cowl firmly planted on your shoulders. The name comes from the Little Waves stitch pattern that creates vertical zigzags.

Finished Size
38¼" (97 cm) bottom circumference and 10" (25.5 cm) long.

Yarn
Chunky weight (#5 Bulky).
Shown here: Quince & Co. Puffin (100% wool; 112 yd [102 m]/3½ oz [100 g]): clay, 2 skeins.

Needles
Size U.S. 11 (8 mm) and 10½ (6.5 mm): 32" (80 cm) circular (cir). *Adjust needle size if necessary to obtain the correct gauge.*

Notions
Stitch marker (m); cable needle (cn); tapestry needle.

Gauge
11 sts and 19 rnds = 4" (10 cm) in Little Waves patt with larger needles.

Stitch Guide

LT (left twist): Sl 1 st onto cn and hold in front of work, k1, k1 from cn.

RT (right twist): Sl 1 st onto cn and hold in back of work, k1, k1 from cn.

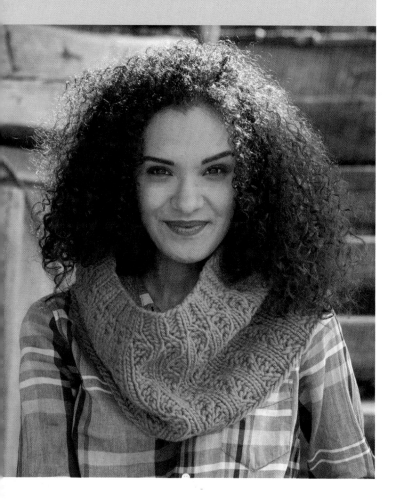

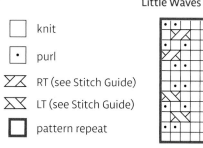

Little Waves Chart

☐	knit
•	purl
⤫	RT (see Stitch Guide)
⤬	LT (see Stitch Guide)
☐	pattern repeat

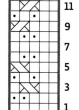

Cowl

With larger cir needle, use long-tail method (see Glossary) to CO 105 sts. Place marker (pm) and join for working in rnds, being careful not to twist sts.

Begin Little Waves Pattern (also see chart)

Rnd 1: Knit.

Rnd 2: *K3, p2; rep from * to end.

Rnd 3: *K2, LT (see Stitch Guide), k1; rep from * to end.

Rnd 4: *K2, p1, k1, p1; rep from * to end.

Rnd 5: *K3, LT; rep from * to end.

Rnd 6: *K2, p2, k1; rep from * to end.

Rnd 7: Knit.

Rnd 8: *K2, p2, k1; rep from * to end.

Rnd 9: *K3, RT (see Stitch Guide); rep from * to end.

Rnd 10: *K2, p1, k1, p1; rep from * to end.

Rnd 11: *K2, RT, k1; rep from * to end.

Rnd 12: *K3, p2; rep from * to end.

Rep Rnds 1–12 two more times, then rep Rnds 1–6 once more. Piece should measure about 8¾" (22 cm) from beg.

Begin Shaping

Rnd 1: Knit.

Rnd 2 (dec): *K2tog, k1, p2; rep from * to end—84 sts rem.

Rnd 3: *K1, LT, p1; rep from * to end.

Rnd 4: *K1, p1; rep from * to end.

Rnd 5: *K2, LT; rep from * to end.

Rnd 6: *K1, [p2, k2] to last st, k1.

Change to smaller cir needle. Rep last row 2 more times.

BO all sts in patt.

Finishing

Weave in ends. Wet-block to measurements.

Felted Joins for Wool Yarns

The Little Waves Cowl uses a bulky yarn that is not superwash (superwash yarns are treated so they will not felt). It's easy to join a new ball of non-superwash wool because the joins can easily be felted.

To attach a new ball, pull apart the fibers at the end of the old ball, removing about half of the fibers from the center. Do the same to one end of the new ball. Twist the new and old ends together so they overlap where they were thinned out and dampen them with water. Roll ends together back and forth vigorously until they "felt" together. The fibers will now be locked together with a permanent and invisible join.

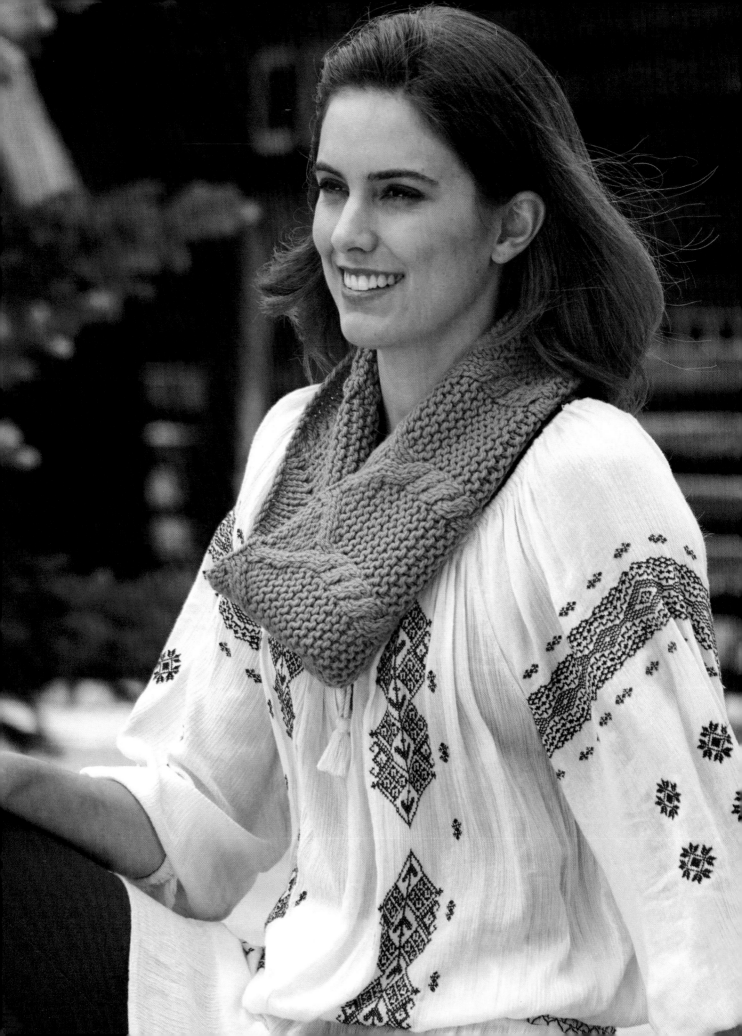

Designed by Emma Welford

Post & Beam Cowl

Inspired by the lines of post-and-beam construction, this textural cowl adds dimension to any outfit. Cables, set against a garter-stitch background, mimic wooden posts before opening up to reflect the characteristic V-shape of framework. Bulky wool means you can whip this up in a fall weekend for a dose of instant gratification, while the warmth of wool makes it a season-spanning accessory.

Finished Size
29" (74 cm) circumference and 7½" (19 cm) long.

Yarn
Aran weight (#4 Medium).

Shown here: Quince & Co. Osprey (100% wool; 170 yd [155 m]/3½ oz [100 g]): split pea, 1 skein.

Needles
Size U.S. 10 (6 mm): 24" (60 cm) circular (cir).

Adjust needle size if necessary to obtain the correct gauge.

Notions
Stitch markers (m); cable needle (cn); tapestry needle.

Gauge
11½ sts and 22½ rows = 4" (10 cm) in garter stitch.

Notes
Cowl is worked in the round. Stitch pattern is given in both chart and written form, and the pattern repeats eight times around the body of the cowl. You may find it helpful to separate each pattern repeat with a stitch marker, but it is not required.

Stitch Guide

2/2LC (2 over 2 left cross): Sl 2 sts onto cn, hold in front of work, k2, k2 from cn.

2/1RPC (2 over 1 right purl cross): Sl 1 st onto cn, hold in back of work, k2, p1 from cn.

2/1LPC (2 over 1 left purl cross): Sl 2 sts onto cn, hold in front of work, p1, k2 from cn.

Post and Beam Pattern (multiple of 12 sts)

Rnd 1: Knit.

Rnds 2, 4, 6, and 8: *P4, k4, p4; rep from * to end.

Rnds 3 and 7: *K4, 2/2LC, k4; rep from * to end.

Rnds 5 and 9: Rep Rnd 1.

Rnd 10: Rep Rnd 2.

Rep Rnds 3–10 three more times.

Rnd 11: *K3, 2/1RPC, 2/1LPC, k3; rep from * to end.

Rnd 12: *P3, k2, p2, k2, p3; rep from * to end.

Rnd 13: *K2, 2/1RPC, p2, 2/1LPC, k2; rep from * to end.

Rnd 14: *P2, k2, p4, k2, p2; rep from * to end.

Rnd 15: *K1, 2/1RPC, p4, 2/1LPC, k1; rep from * to end.

Rnd 16: *P1, k2, p6, k2, p1; rep from * to end.

Rnd 17: *2/1RPC, p6, 2/1LPC; rep from * to end.

Rnd 18: *K2, p8, k2; rep from * to end.

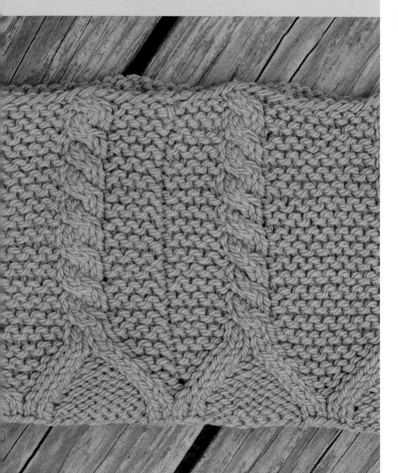

Cowl

CO 96 sts. Place marker (pm) and join for working in rnds, being careful not to twist sts.

Rnd 1: Work Rnd 1 of Post and Beam patt (see Stitch Guide or chart).

Work Rnds 2–10 once, rep Rnds 3–10 three more times. Work Rnds 11–18 once.

BO all sts in patt.

Finishing

Weave in all ends. Block to finished measurements.

Post and Beam Chart

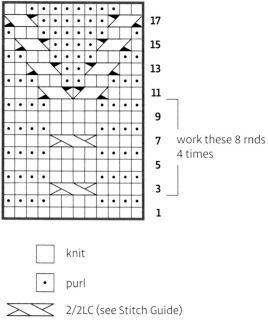

work these 8 rnds 4 times

☐ knit

• purl

2/2LC (see Stitch Guide)

2/1LPC (see Stitch Guide)

2/1RPC (see Stitch Guide)

☐ pattern repeat

Keeping Track of Pattern Repeats

When a stitch pattern is repeated several times around the circumference of a piece, it can sometimes be difficult to keep your place in the pattern. If you find that you have difficulty keeping track, try placing contrasting stitch markers after each pattern repeat. This way, you can catch errors within each repeat, rather than reaching the end of a round and finding that you have too many or too few stitches to complete the pattern.

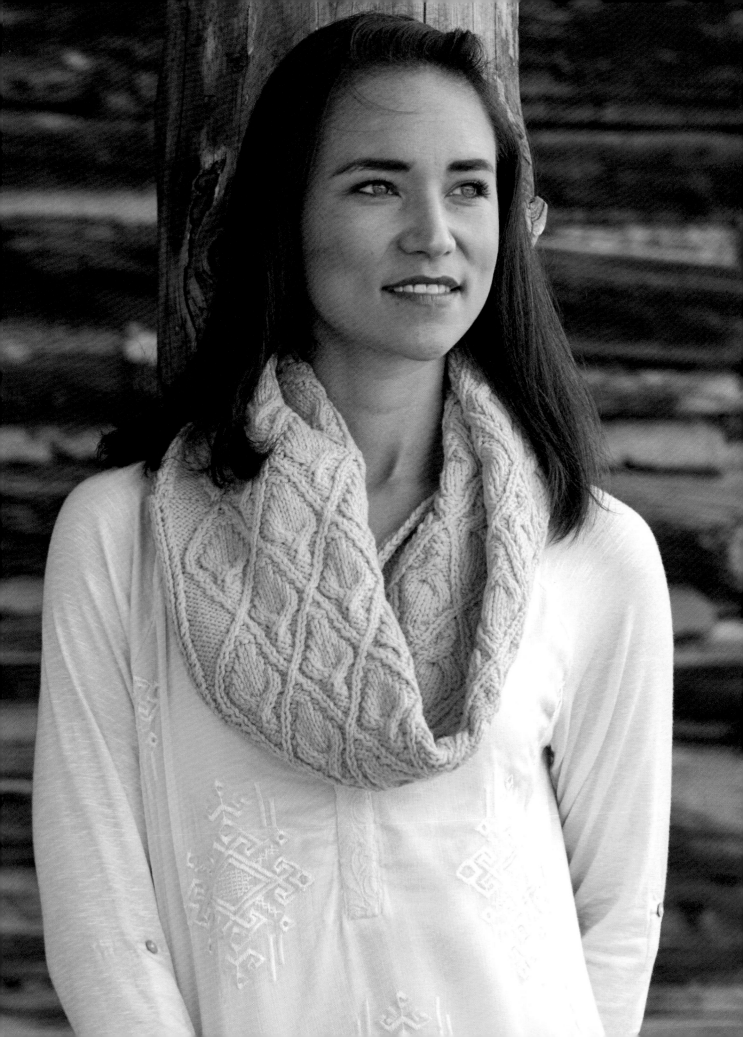

Designed by Thea Colman

Warm Cider Cowl

This cowl is light and warm, perfect for a walk through the leaves on a brisk afternoon. The motif within the diamonds is a nod to those fallen leaves and the noise they make as you explore trails in the woods during early fall. The diamond motif is a simple pattern to memorize and makes for a perfect project to knit after a walk with a steaming mug of warm cider nearby.

Finished Size
36" (91.5 cm) circumference and 12½" (31.5 cm) wide.

Yarn
Worsted weight (#4 Medium).

Shown here: Quince & Co. Lark (100% wool; 134 yd [123 m]/1¾ oz [50 g]): goldfinch, 5 skeins.

Needles
Size U.S. 7 (4.5 mm) needles. *Adjust needle size if necessary to obtain the correct gauge.*

Notions
Cable needle (cn); tapestry needle.

Gauge
26 sts and 28 rows = 4" (10 cm) in Leaves and Diamonds patt.

Notes
Cowl is worked back and forth as a long strip, then the ends are sewn together to form a loop. This cowl could easily be modified for length or width by working more or fewer repeats of the pattern.

Stitch Guide

LT (left twist): Sl 1 st onto cn and hold in front of work, k1, k1 from cn.

RT (right twist): Sl 1 st onto cn and hold in back of work, k1, k1 from cn.

2/2LC (2 over 2 left cross): Sl 2 sts onto cn and hold in front of work, k2, k2 from cn.

2/2RC (2 over 2 right cross): Sl 2 sts onto cn and hold in back of work, k2, k2 from cn.

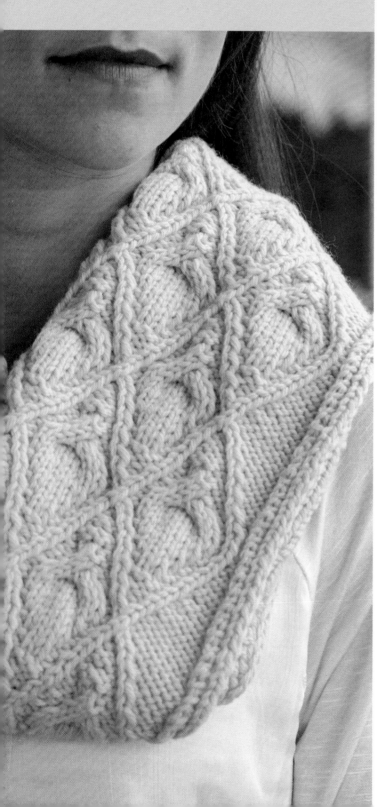

Cowl

CO 80 sts.

Set-up row: (WS) Sl 1 pwise, p3, k7, p1, [p1, k2, p8, k2, p1] 4 times, p1, k7, p3, sl 1 pwise.

Begin Leaves and Diamonds Patt (also see chart on page 22)

Row 1: (RS) K1-tbl, k1, yo, ssk, p7, [RT (see Stitch Guide), p2, k8, p2] 4 times, RT, p7, k2tog, yo, k1, k1-tbl.

Row 2: (WS) Sl 1 pwise, p3, k7, p1, [p1, k2, p8, k2, p1] 4 times, p1, k7, p3, sl 1 pwise.

Row 3: K1-tbl, k1, yo, ssk, p6, RT, [LT (see Stitch Guide), p2, k6, p2, RT] 4 times, LT, p6, k2tog, yo, k1, k1-tbl.

Row 4: Sl 1 pwise, p3, k6, p1, k1, [k1, p1, k2, p6, k2, p1, k1] 4 times, k1, p1, k6, p3, sl 1 pwise.

Row 5: K1-tbl, k1, yo, ssk, p5, RT, p1, [p1, LT, p2, k4, p2, RT, p1] 4 times, p1, LT, p5, k2tog, yo, k1, k1-tbl.

Row 6: Sl 1 pwise, p3, k5, p1, k2, [k2, p1, k2, p4, k2, p1, k2] 4 times, k2, p1, k5, p3, sl 1 pwise.

Row 7: K1-tbl, k1, yo, ssk, p4, RT, p2, [p2, LT, p2, k2, p2, RT, p2] 4 times, p2, LT, p4, k2tog, yo, k1, k1-tbl.

Row 8: Sl 1 pwise, p3, k4, p1, k2, p1, [(p1, k2) twice, p2, (k2, p1) twice] 4 times, p1, k2, p1, k4, p3, sl 1 pwise.

Row 9: K1-tbl, k1, yo, ssk, p3, RT, p2, k1, [k1, p2, LT, p4, RT, p2, k1] 4 times, k1, p2, LT, p3, k2tog, yo, k1, k1-tbl.

Row 10: Sl 1 pwise, p3, k3, p1, k2, p2, [p2, k2, p1, k4, p1, k2, p2] 4 times, p2, k2, p1, k3, p3, sl 1 pwise.

Row 11: K1-tbl, k1, yo, ssk, p2, RT, p2, [2/2RC (see Stitch Guide), p2, LT, p2, RT, p2] 4 times, 2/2RC, p2, LT, p2, k2tog, yo, k1, k1-tbl.

Row 12: Sl 1 pwise, p3, k2, p1, k2, p3, [p3, (k2, p1) twice, k2, p3] 4 times, p3, k2, p1, k2, p3, sl 1 pwise.

Row 13: K1-tbl, k1, yo, ssk, p1, RT, p1, 2/2RC, [2/2LC (see Stitch Guide), p1, LT, RT, p1, 2/2RC] 4 times, 2/2LC, p1, LT, p1, k2tog, yo, k1, k1-tbl.

Rows 14 and 16: Sl 1 pwise, p3, k1, p1, k2, p4, [p4, k2, p2, k2, p4] 4 times, p4, k2, p1, k1, p3, sl 1 pwise.

Row 15: K1-tbl, k1, yo, ssk, p1, k1, p2, k4, [k4, p2, RT, p2, k4] 4 times, k4, p2, k1, p1, k2tog, yo, k1, k1-tbl.

Row 17: K1-tbl, k1, yo, ssk, p1, LT, p2, k3, [k3, p2, RT, LT, p2, k3] 4 times, k3, p2, RT, p1, k2tog, yo, k1, k1-tbl.

Row 18: Rep Row 12.

Row 19: K1-tbl, k1, yo, ssk, p2, LT, p2, k2, [k2, p2, RT, p2, LT, p2, k2] 4 times, k2, p2, RT, p2, k2tog, yo, k1, k1-tbl.

Row 20: Rep Row 10.

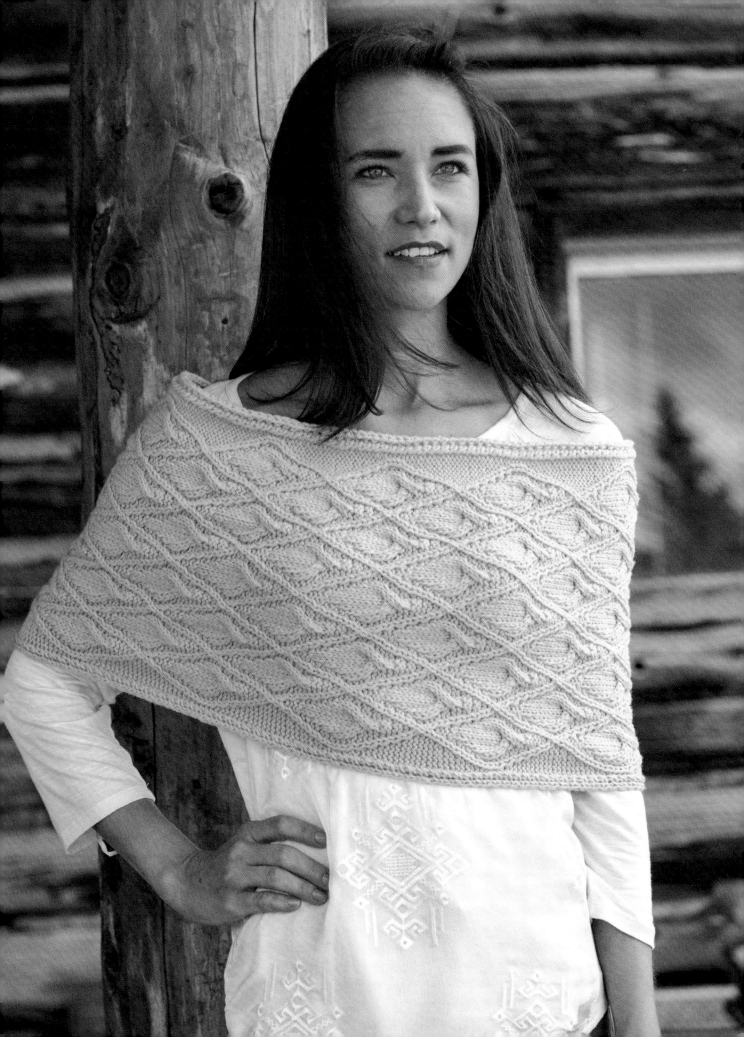

Row 21: K1-tbl, k1, yo, ssk, p3, LT, p2, k1, [k1, p2, RT, p4, LT, p2, k1] 4 times, k1, p2, RT, p3, k2tog, yo, k1, k1-tbl.

Row 22: Rep Row 8.

Row 23: K1-tbl, k1, yo, ssk, p4, LT, p2, [p2, RT, p2, k2, p2, LT, p2] 4 times, p2, RT, p4, k2tog, yo, k1, k1-tbl.

Row 24: Rep Row 6.

Row 25: K1-tbl, k1, yo, ssk, p5, LT, p1, [p1, RT, p2, 2/2RC, p2, LT, p1] 4 times, p1, RT, p5, k2tog, yo, k1, k1-tbl.

Row 26: Rep Row 4.

Row 27: K1-tbl, k1, yo, ssk, p6, LT, [RT, p1, 2/2RC, 2/2LC, p1, LT] 4 times, RT, p6, k2tog, yo, k1, k1-tbl.

Row 28: Rep Row 2.

Rep Rows 1–28 eight more times.

BO all sts in patt.

Finishing

Weave in ends. Block to finished measurements.

Sew BO and CO ends tog using mattress st (see Glossary).

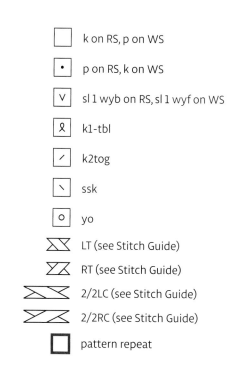

☐	k on RS, p on WS
•	p on RS, k on WS
V	sl 1 wyb on RS, sl 1 wyf on WS
ℛ	k1-tbl
╱	k2tog
╲	ssk
o	yo
⟋⟍	LT (see Stitch Guide)
⟍⟋	RT (see Stitch Guide)
⟋⟍	2/2LC (see Stitch Guide)
⟍⟋	2/2RC (see Stitch Guide)
☐	pattern repeat

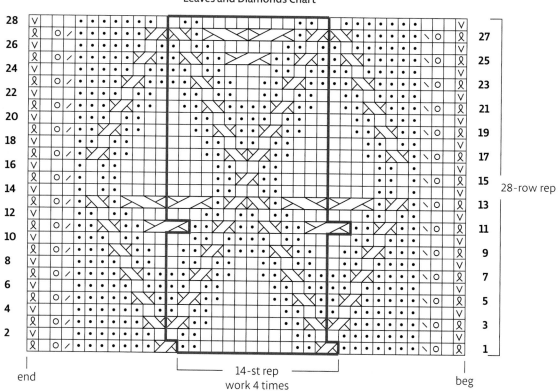

Leaves and Diamonds Chart

28-row rep

14-st rep
work 4 times

end

beg

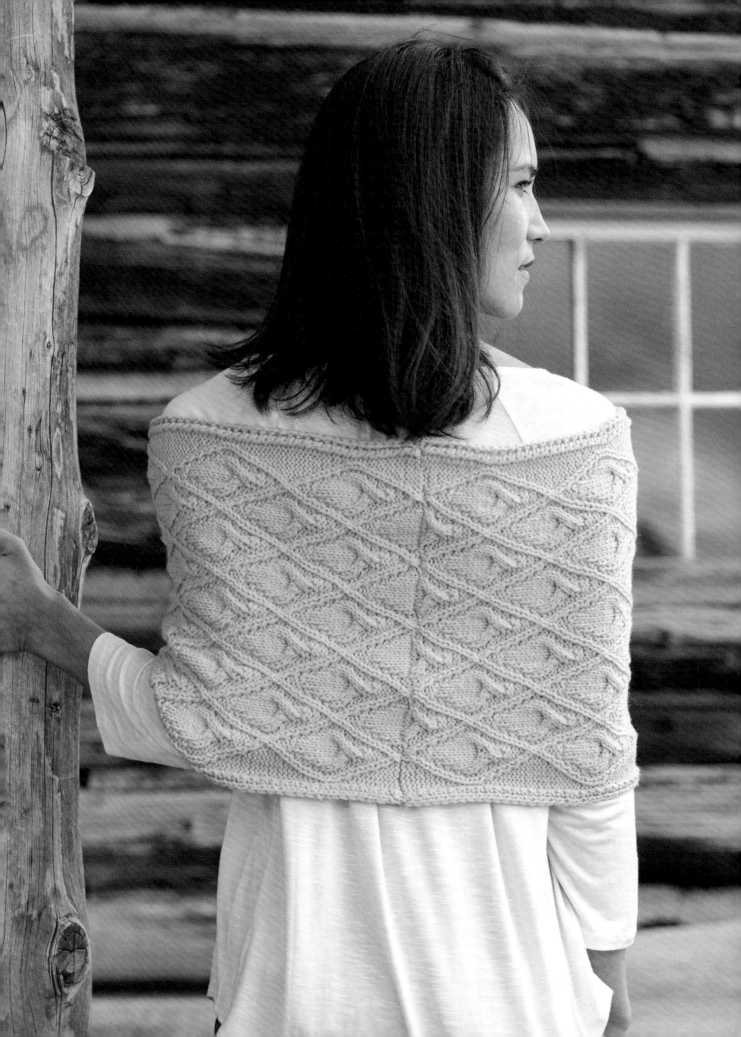

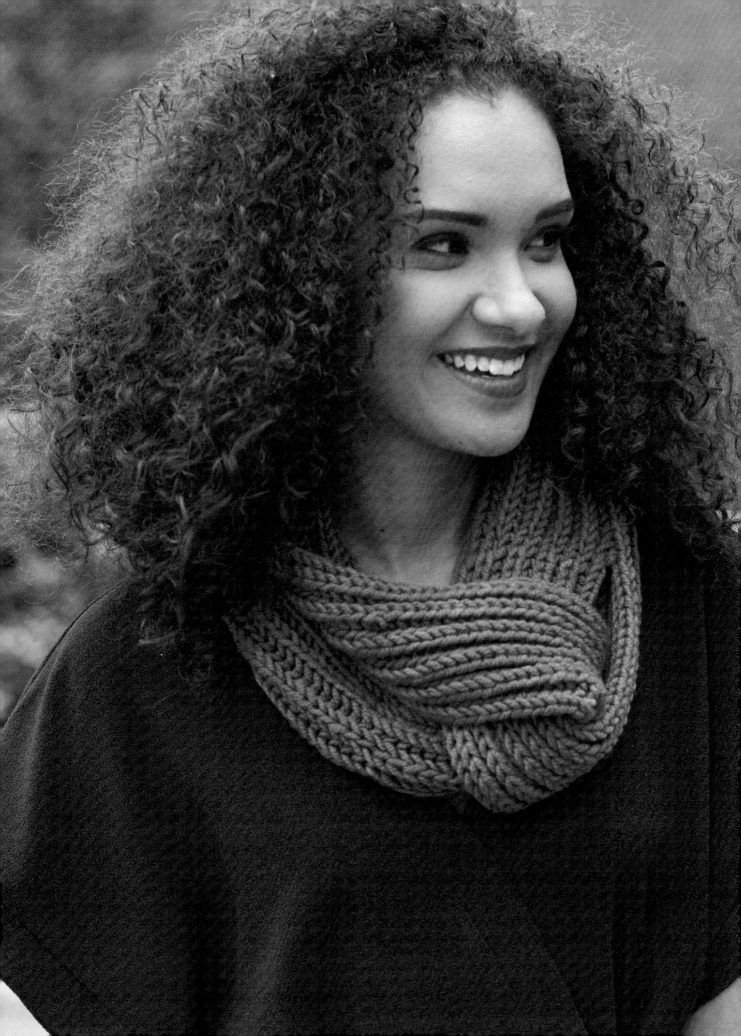

Designed by Angela Tong

Interlock Cowl

The Interlock Cowl is knit with bulky yarn and brioche stitch to create a simple yet decorative cowl. The interlocking design is made by knitting the cowl in two pieces, then looping them together and joining. It's a quick knit with a luxurious chunky yarn. It takes only a day to whip up this warm and cushy neck warmer.

Finished Size
24" (61 cm) circumference and 8" (20.5 cm) wide, blocked.

Yarn
Chunky weight (#5 Bulky).

Shown here: Lorna's Laces Cloudgate (90% superwash merino wool, 10% nylon; 120 yd [110 m]/3½ oz [100 g]): 14NS denim, 2 skeins.

Needles
Size U.S. 10½ (6.5 mm): 24" (60 cm) circular (cir).
Adjust needle size if necessary to obtain the correct gauge.

Notions
Waste yarn; stitch holder; spare needle in same size; tapestry needle.

Gauge
12 sts and 32 rows = 4" (10 cm) in pattern st, blocked.

Note: Since each stitch is worked only once every two rows, the number of rows actually worked is double what it appears to be.

Notes
The cowl is knit in two pieces and joined using three-needle bind-off (see Glossary). The first loop is knit and then the second loop is slipped through the first loop to connect the two pieces before the second loop is joined together.

First Loop

CO 18 sts using provisional method (see Glossary).

Set-up row: (RS) *Sl1yo (see Glossary), k2tog; rep from * to end—12 sts rem.

Row 1: *Sl1yo, brk1 (see Glossary); rep from * to end.

Rep Row 1 until piece measures 10" (25.5 cm) from CO.

Turn work. Carefully remove waste yarn from provisional CO and place resulting 18 sts onto left needle tip—30 sts **(Figure 1)**.

Joining row: Work 12 sts in established patt, *sl1yo, k2tog; rep from * to end—24 sts.

Rep Row 1 until piece measures about 8¾" (22 cm) from join, ending with a WS row.

Next row: (RS) Sl 1, *brk1, p1; rep from * to last sl1yo, brk1—24 sts. Place sts onto holder. Cut yarn, leaving a 6" (15 cm) tail.

1

Second Loop

CO 18 sts using provisional method.

Set-up row: (RS) *Sl1yo, k2tog; rep from * to end—12 sts.

Row 1: (WS) *Sl1yo, brk1; rep from * to end.

Rep Row 1 until piece measures 10" (25.5 cm) from CO.

Turn work. Slip CO edge through opening in first loop **(Figures 2 and 3)**. Carefully remove scrap yarn from provisional CO and place resulting 18 sts onto left needle tip—30 sts **(Figure 4)**.

Joining row: Work 12 sts in established patt, *sl1yo, k2tog; rep from * to end—24 sts.

Rep Row 1 until piece measures about 8¾" (22 cm) from join, ending with a WS row.

Next row: (RS) Sl 1, *brk1, p1; rep from * to last sl1yo, brk1—24 sts.

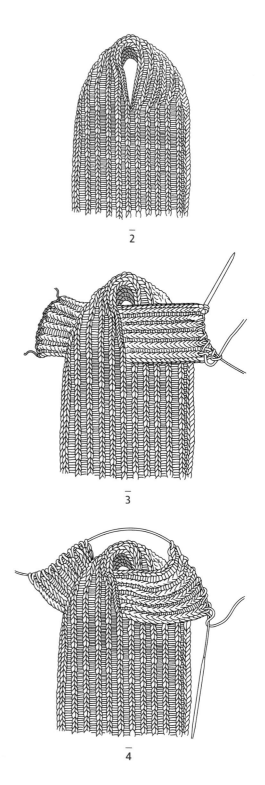

2

3

4

Finishing

Join ends of cowl using three-needle BO (see Glossary).

Weave in ends. Steam block lightly.

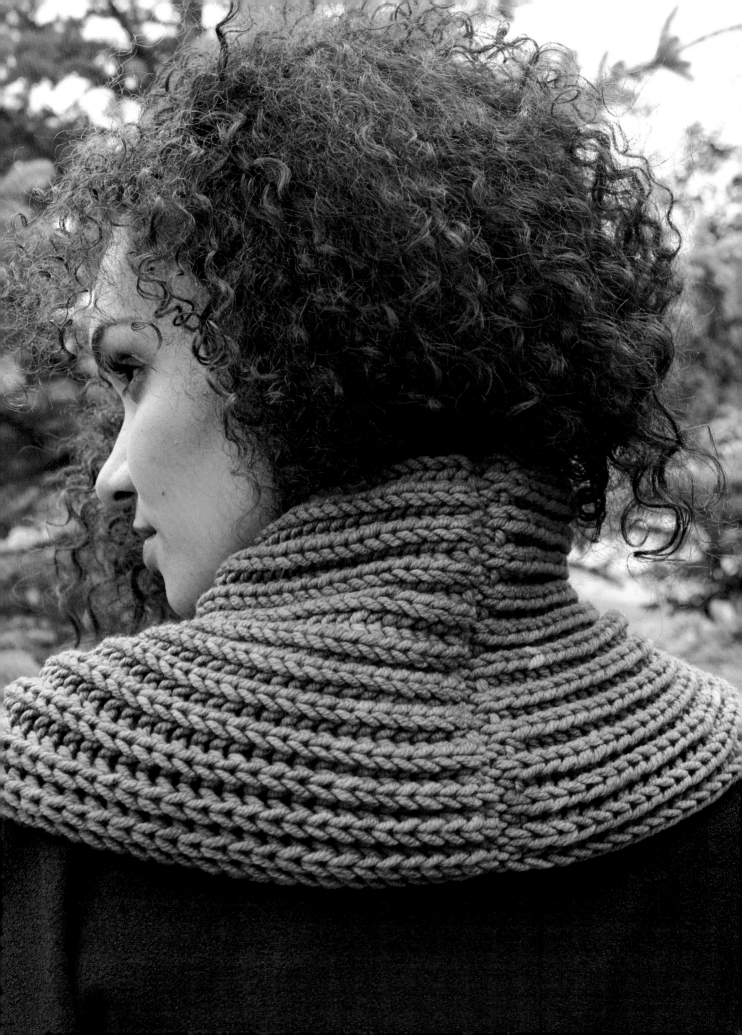

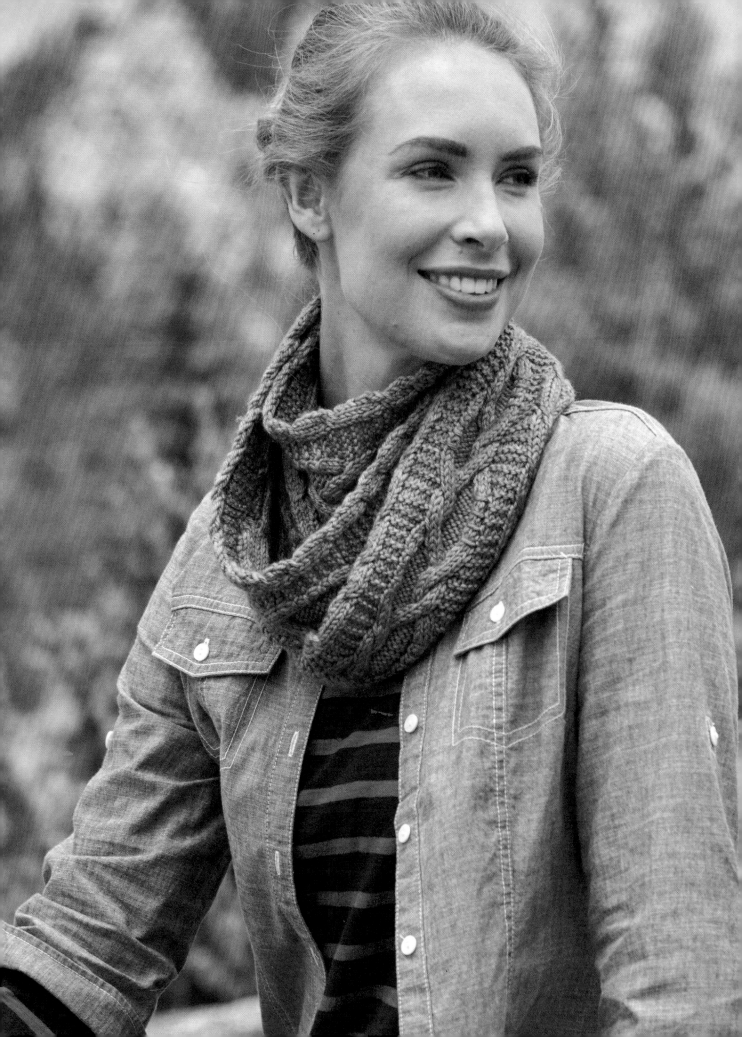

Designed by Rachel Stecker

Wantastiquet Cowl

This cowl is inspired by the trail on Wantastiquet Mountain in southern New Hampshire. On the ascent you can take the long, winding trails or, if you're slightly more daring, you can traverse the steep and rocky cut-throughs. The movement of cables in this extra-long cowl, as well as the way it's worn, reflects the beauty of the designer's favorite spot.

Finished Size
75" (190.5 cm) circumference and 4½" (11.5 cm) wide.

Yarn
Worsted weight (#4 Medium).

Frabjous Fibers/Wonderland Yarns March Hare (100% superwash merino wool; 184 yd [168 m]/4 oz [113 g]): #36 tumtum tree, 2 skeins.

Needles
Size U.S. 7 (4.5 mm) needles. *Adjust needle size if necessary to obtain the correct gauge.*

Notions
Waste yarn; cable needle (cn); tapestry needle.

Gauge
27½ sts and 25½ rows = 4" (10 cm) in chart patt.

Notes
The Wantastiquet Cowl is knit flat, starting with a provisional cast-on, and then the ends are grafted together when work is complete.

Slip the first stitch of every row purlwise with the yarn in back of the work unless otherwise instructed.

Stitch Guide

2/2LC (2 over 2 left cross): Sl 2 sts onto cn and hold in front of work, k2, k2 from cn.

2/2RC (2 over 2 right cross): Sl 2 sts onto cn and hold in back of work, k2, k2 from cn.

3/1LC (3 over 1 left cross): Sl 3 sts onto cn and hold in front of work, k1, k3 from cn.

3/1LPC (3 over 1 left purl cross): Sl 3 sts onto cn and hold in front of work, p1, k3 from cn.

3/1RC (3 over 1 right cross): Sl 1 st onto cn and hold in back of work, k3, k1 from cn.

3/1RPC (3 over 1 right purl cross): Sl 1 st onto cn and hold in back of work, k3, p1 from cn.

3/2LPC (3 over 2 left purl cross): Sl 3 sts onto cn and hold in front of work, p2, k3 from cn.

3/2RPC (3 over 2 right purl cross): Sl 2 sts onto cn and hold in back of work, k3, p2 from cn.

3/3RC (3 over 3 right cross): Sl 3 sts onto cn and hold in back of work, k3, k3 from cn.

3/3LC (3 over 3 left cross): Sl 3 sts onto cn and hold in front of work, k3, k3 from cn.

Cluster 3: Sl 3 sts onto right needle tip with yarn in front, bring yarn to back, sl 3 sts back to left needle tip, k3 sts just slipped.

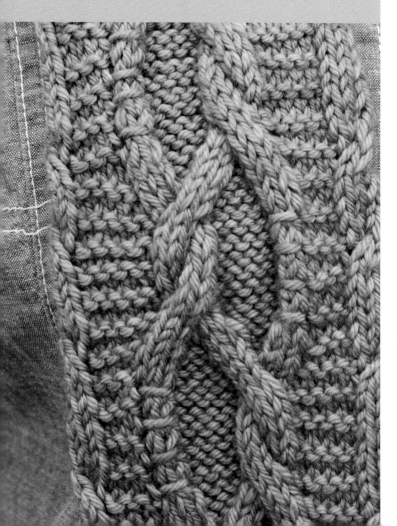

Cowl

CO 31 sts using provisional method (see Glossary).

Begin Cable Patt (also see chart on page 32)

Row 1: (WS) P4, k4, [p3, k3] twice, p3, k4, p3, k1-tbl.

Row 2: (RS) Sl 1, k7, 3/1LC (see Stitch Guide), 3/2RPC (see Stitch Guide), p3, 3/1LPC (see Stitch Guide), k6, k1-tbl.

Row 3: Sl 1, p3, k3, p3, k6, p6, k5, p3, k1-tbl.

Row 4: Sl 1, k8, 3/3RC (see Stitch Guide), p6, Cluster 3 (see Stitch Guide), k6, k1-tbl.

Rows 5, 7, and 9: Sl 1, p3, k3, p3, k6, p6, k5, p3, k1-tbl.

Row 6: 2/2LC (see Stitch Guide), k11, p6, Cluster 3, k3, 2/2RC (see Stitch Guide).

Row 8: Sl 1, k14, p6, Cluster 3, k6, k1-tbl.

Row 10: Rep Row 4.

Row 11: Rep Row 5.

Row 12: Sl 1, k7, 3/1RPC (see Stitch Guide), 3/2LPC (see Stitch Guide), p3, 3/1RC (see Stitch Guide), k6, k1-tbl.

Row 13: Sl 1, p3, k4, [p3, k3] twice, p3, k4, p3, k1-tbl.

Row 14: 2/2LC, k3, 3/1RPC, p3, 3/2LPC, 3/1RC, k4, 2/2RC.

Row 15: Sl 1, p3, k5, p6, k6, p3, k3, p3, k1-tbl.

Row 16: Sl 1, k6, Cluster 3, p6, 3/3LC (see Stitch Guide), k8, k1-tbl.

Rows 17, 19, and 21: Sl 1, p3, k5, p6, k6, p3, k3, p3, k1-tbl.

Rows 18 and 20: Sl 1, k6, Cluster 3, p6, k14, k1-tbl.

Row 22: Rep Row 16.

Row 23: Rep Row 17.

Row 24: 2/2LC, k3, 3/1LC, p3, 3/2RPC, 3/1LPC, k4, 2/2RC.

Row 25: Sl 1, p3, k4, [p3, k3] twice, p3, k4, p3, k1-tbl.

Rep Rows 2–25 eighteen more times.

Rep Rows 2–24 once more.

Do not cut yarn.

Finishing

Graft ends together using Kitchener stitch (see Glossary).

Weave in ends. Block to finished measurements.

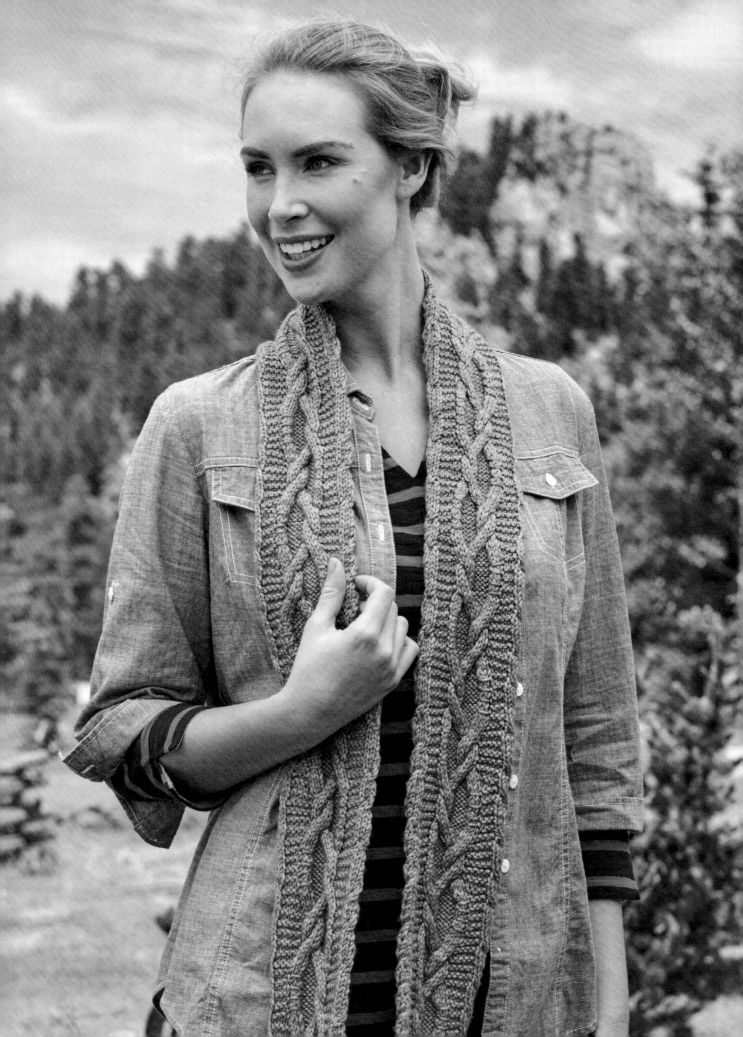

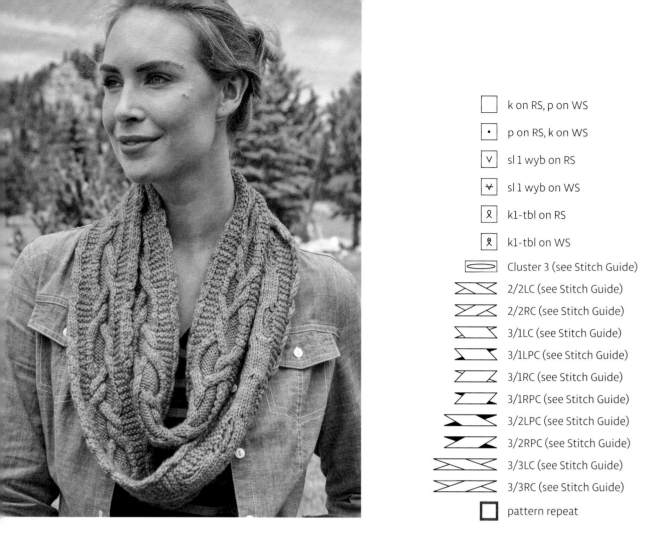

□	k on RS, p on WS	
•	p on RS, k on WS	
V	sl 1 wyb on RS	
⅄	sl 1 wyb on WS	
ℓ	k1-tbl on RS	
ℓ	k1-tbl on WS	
⬭	Cluster 3 (see Stitch Guide)	
⧓	2/2LC (see Stitch Guide)	
⧓	2/2RC (see Stitch Guide)	
⟋	3/1LC (see Stitch Guide)	
◤	3/1LPC (see Stitch Guide)	
⟍	3/1RC (see Stitch Guide)	
◥	3/1RPC (see Stitch Guide)	
⬱	3/2LPC (see Stitch Guide)	
⬰	3/2RPC (see Stitch Guide)	
⧅	3/3LC (see Stitch Guide)	
⧄	3/3RC (see Stitch Guide)	
□	pattern repeat	

Cable Chart

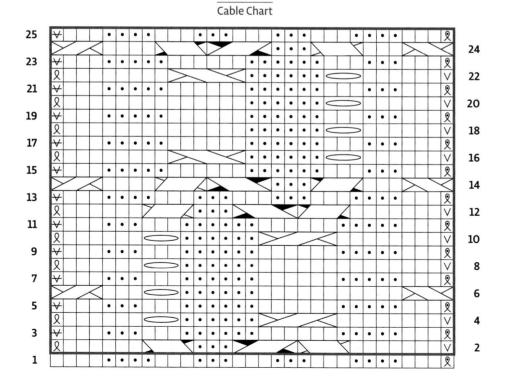

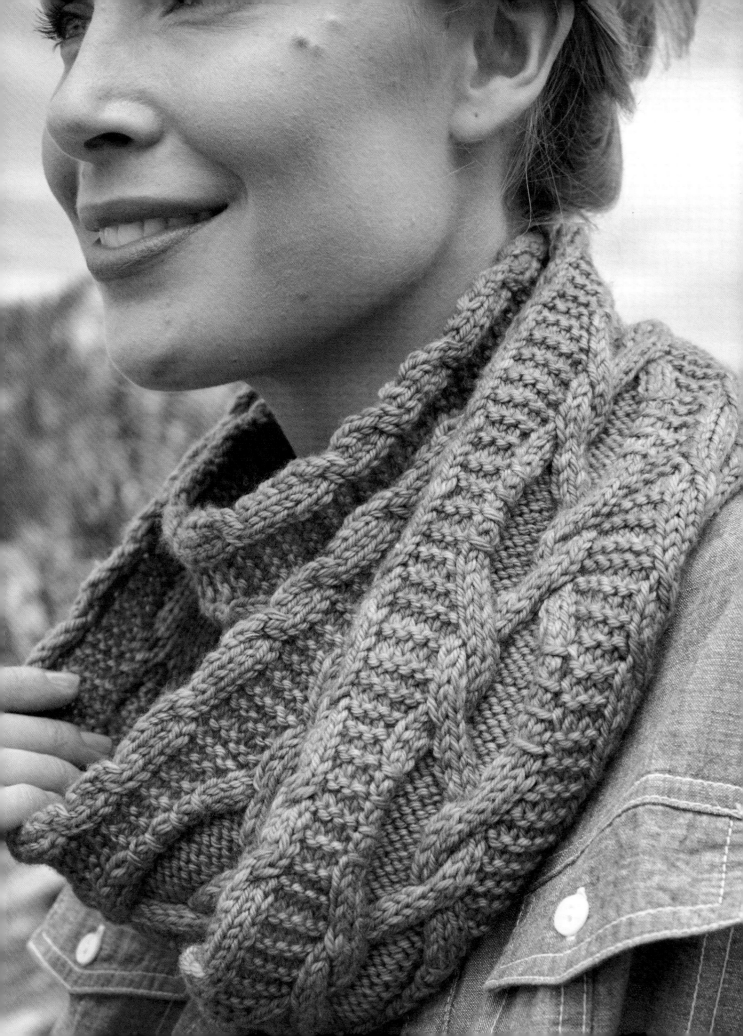

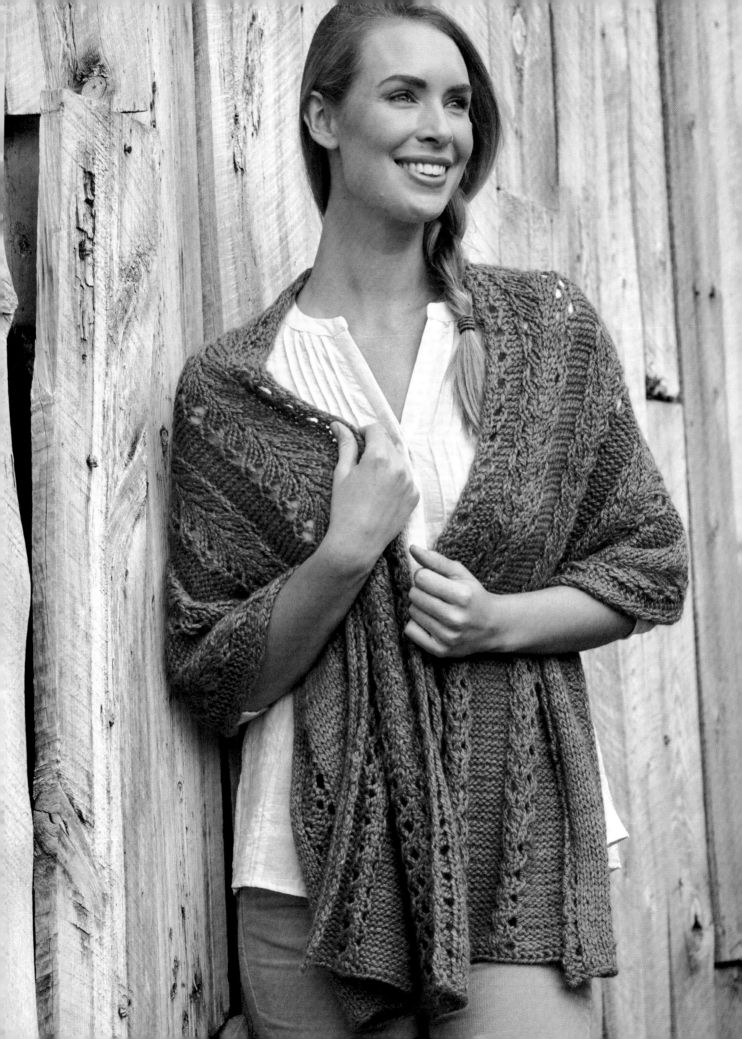

Cozy Shawls

Delicate lace-weight shawls are great, but there's nothing quite like the feel of a worsted-weight shawl when you're really looking to add a layer of warmth. Throw one of these over your shoulders in place of a cardigan when the sun goes down or wrap it around your neck and shoulders on a winter day for a more substantial scarf.

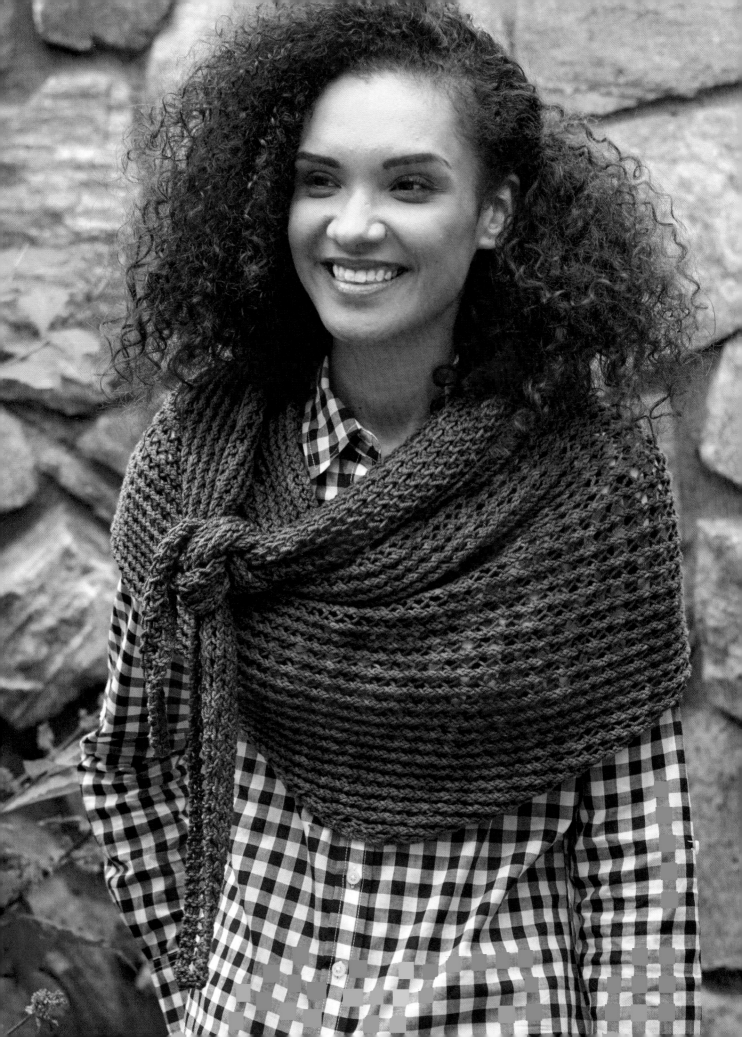

Designed by Angela Tong

Turkish Lace Shawl

The shawl is knit from end to end all in one piece. It's a shallow triangle shape with long ends. The overall lace pattern used on the shawl is an easy Turkish lace stitch. Although it has a right and wrong side, the wrong side is just as attractive as the right side. It's a comfy and stylish accessory for lounging around on the weekends or for heading out to the farmer's market.

Finished Size
95¼" (242 cm) long and 18¼" (46.5 cm) wide, blocked.

Yarn
Worsted weight (#4 Medium).

Shown here: Mrs. Crosby Steamer Trunk (100% superwash merino wool; 164 yd [150 m]/3½ oz [100 g]): wild huckleberry, 4 skeins.

Needles
Size U.S. 10½ (6.5 mm): 32" (80 cm) long circular (cir). *Adjust needle size if necessary to obtain the correct gauge.*

Notions
Tapestry needle.

Gauge
15½ sts and 16½ rows = 4" (10 cm) in Mock Turkish Stitch, blocked.

Notes
The shawl begins at one narrow end and increases to the center. Then it decreases to the other narrow end. All the slipped stitches are slipped knitwise.

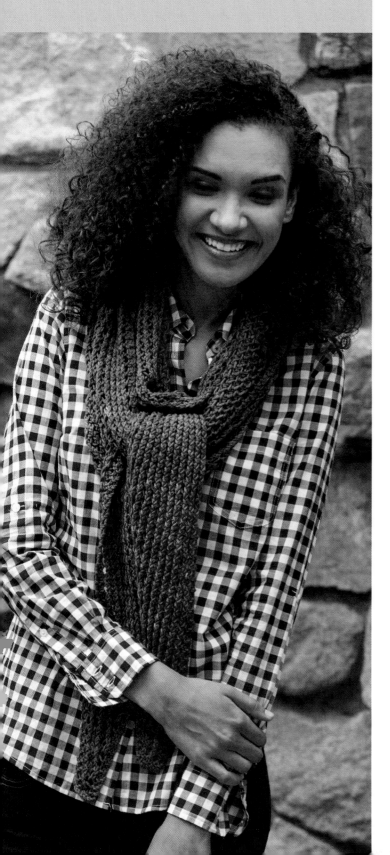

Shawl

CO 6 sts.

Row 1: (RS) Knit.

Row 2: (WS) K2, p2, k2.

Row 3: K2, skp, yo, k2.

Row 4: K2, p2tog, yo, k2.

Row 5 (inc): K2, yo, skp, yo, k2—7 sts.

Row 6: K2, p2tog, yo, p1, k2.

Increase Section

Row 1 (inc): (RS) K2, k1, yo, *skp, yo; rep from * to last 2 sts, k2—1 st inc'd.

Row 2: (WS) K2, *p2tog, yo; rep from * to last 4 sts, p2, k2.

Row 3: K2, *skp, yo; rep from * to last 2 sts, k2.

Row 4: K2, *p2tog, yo; rep from * to last 2 sts, k2.

Row 5 (inc): K2, yo, *skp, yo; rep from * to last 2 sts, k2—1 st inc'd.

Row 6: K2, *p2tog, yo; rep from * to last 3 sts, p1, k2.

Rep Rows 1–6 thirty-one more times—71 sts.

Decrease Section

Row 1 (dec): (RS) K1, k2tog, *skp, yo; rep from * to last 2 sts, k2—1 st dec'd.

Row 2: (WS) K2, *p2tog, yo; rep from * to last 2 sts, k2.

Row 3: K2, *skp, yo; rep from * to last 2 sts, k2.

Row 4: K2, *p2tog, yo; rep from * to last 2 sts, k2.

Row 5 (dec): K2, skp, *skp, yo; rep from * to last 2 sts, k2—1 st dec'd.

Row 6: K2, *p2tog, yo; rep from * to last 3 sts, p1, k2.

Rep Rows 1–6 thirty-one more times—7 sts rem.

End

Row 1: K1, k2tog, skp, yo, k2—6 sts rem.

Row 2: K2, p2, k2.

Row 3: Knit.

BO all sts kwise.

Finishing

Weave in ends. Wet-block to 101" (256.5 cm) long and 19" (48.5 cm) wide. Shawl will relax to finished measurements after unpinning.

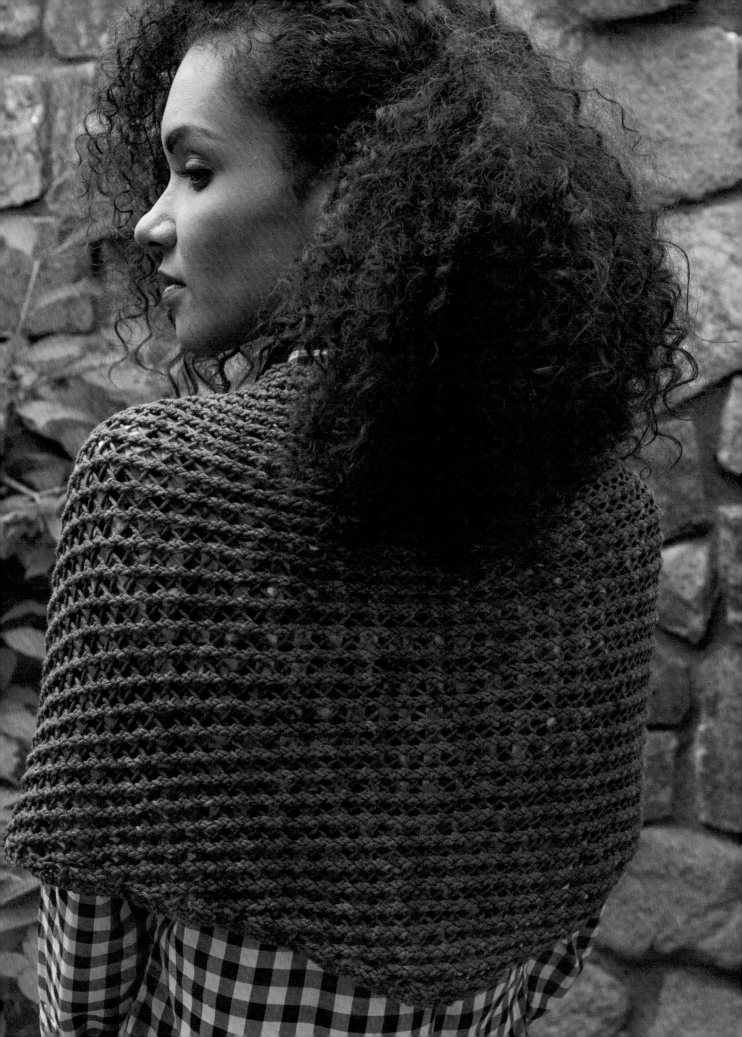

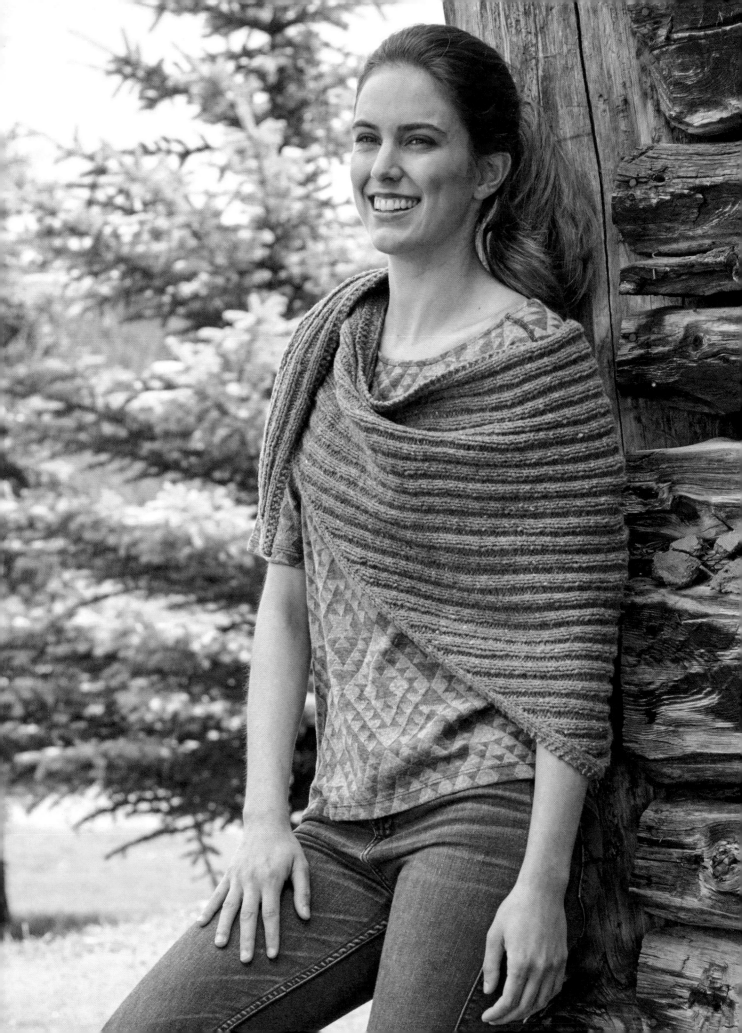

Designed by Melissa LaBarre

Hiker's Shawl

This shawl begins in a very nontraditional way. Starting at the center, stitches are cast on and slowly decreased into the ribbing. Later, stitches are picked up from the cast-on edge and then worked in a similar way in the opposite direction. The result is a rustic ribbed shawl that's substantial and warm, but can still be scrunched up and worn like a scarf when desired—perfect for a walk in the woods on a nippy fall day!

Finished Size
62½" (158.5 cm) wide and 21¼" (54 cm) long at center.

Yarn
Worsted weight (#4 Medium).

Shown here: Brooklyn Tweed Shelter (100% wool; 140 yd [128 m]/1¾ oz [50 g]): camper, 5 skeins.

Needles
Size U.S. 8 (5 mm): 32" (80 cm) circular (cir). *Adjust needle size if necessary to obtain the correct gauge.*

Gauge
19½ sts and 26 rows = 4" (10 cm) in 2x2 rib, relaxed.

Notes
This shawl is worked from the center out to one point, then stitches are picked up along the cast-on edge and worked to the other point. Two stitches on each edge are worked in garter stitch for the border.

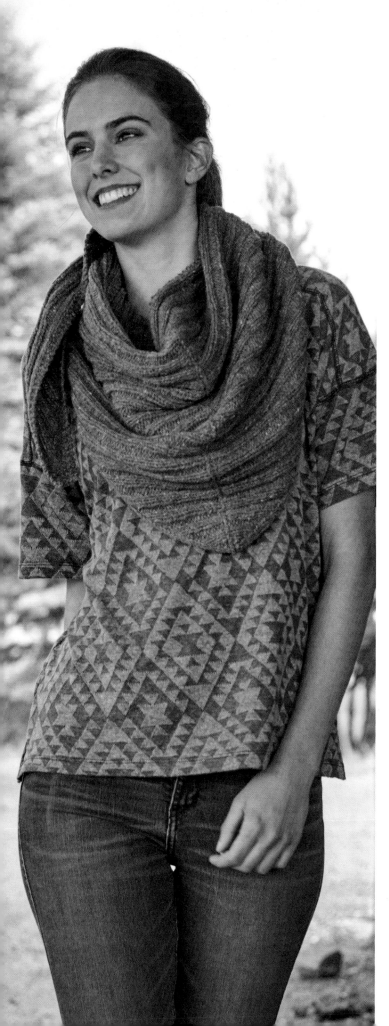

First Half

CO 106 sts. Do not join.

Set-up row: (WS) K2, [p2, k2] to end.

Row 1: (RS) K3, ssk, p1, [k2, p2] to last 4 sts, k4—1 st dec'd.

Row 2: (WS) K2, [p2, k2] to last 7 sts, p2, k1, p2, k2.

Row 3: K3, ssk, [k2, p2] to last 4 sts, k4—1 st dec'd.

Row 4: K2, [p2, k2] to last 6 sts, p4, k2.

Row 5: K3, ssk, k1, [p2, k2] to last 2 sts, k2—1 st dec'd.

Row 6: K2, [p2, k2] to last 5 sts, p3, k2.

Row 7: K3, ssk, [p2, k2] to last 2 sts, k2—1 st dec'd.

Row 8: K2, [p2, k2] to end.

Rep Rows 1–8 twenty-four more times—6 sts rem.

Knit 2 rows even. BO rem sts.

Second Half

With RS facing, pick up and knit 106 sts along CO edge. Do not join.

Next row: (WS) Knit.

Row 1: (RS) K4, [p2, k2] to last 6 sts, p1, k2tog, k3—1 st dec'd.

Row 2: (WS) K2, p2, k1, [k2, p2] to end.

Row 3: K4, [p2, k2] to last 5 sts, k2tog, k3—1 st dec'd.

Row 4: K2, p4, [k2, p2] to last 2 sts, k2.

Row 5: K4, [p2, k2] to last 8 sts, p2, k1, k2tog, k3—1 st dec'd.

Row 6: K2, p3, [k2, p2] to last 2 sts, k2.

Row 7: K4, [p2, k2] to last 7 sts, p2, k2tog, k3—1 st dec'd.

Row 8: K2, [p2, k2] to end.

Rep Rows 1–8 twenty-four more times—6 sts rem.

Knit 2 rows even. BO rem sts.

Finishing

Weave in ends. Block to 68" (172.5 cm) wide along top edge and 24" (61 cm) long along center. Shawl will relax to finished measurements after blocking.

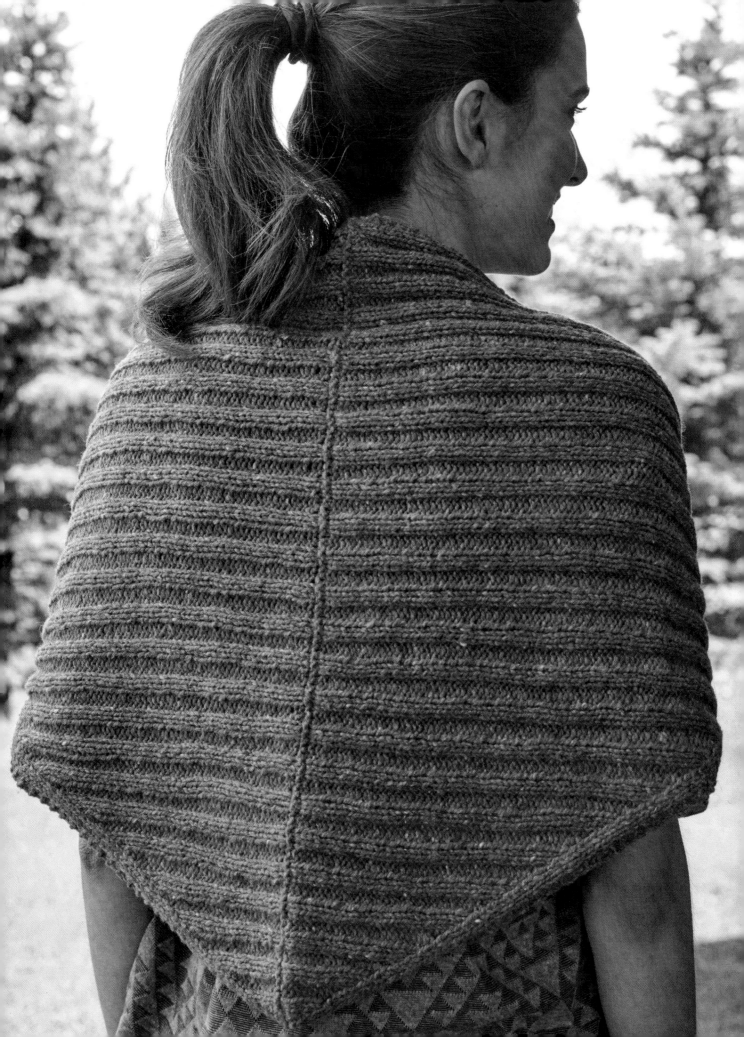

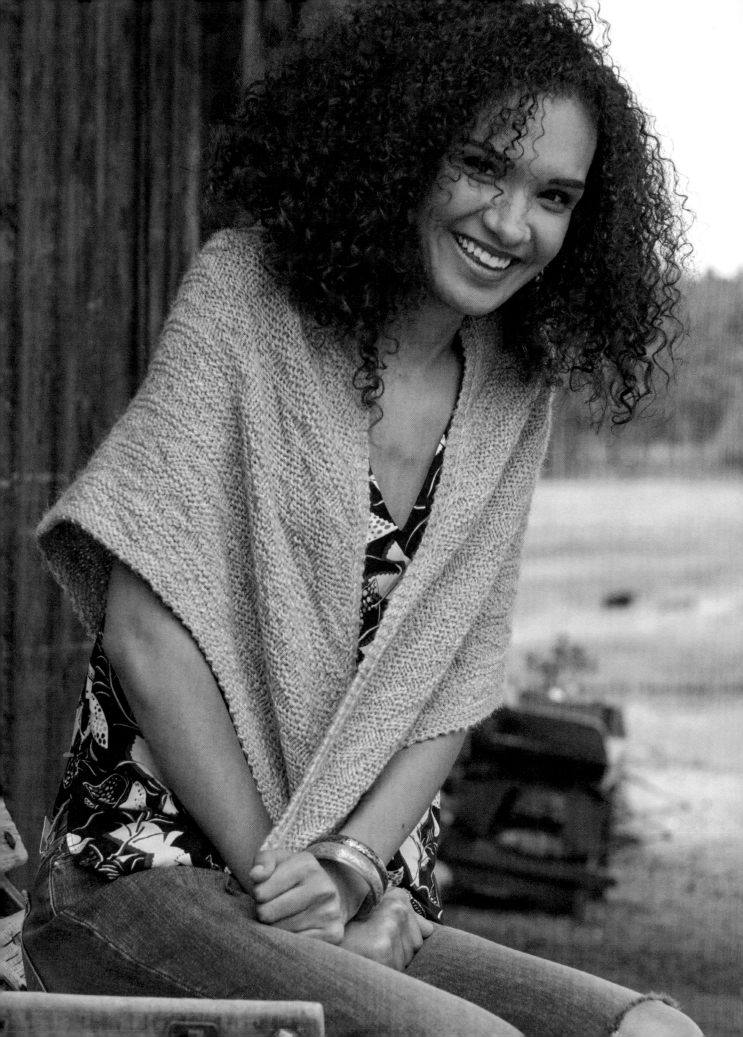

Designed by Kate Gagnon Osborn

Inspired by traditional fishermen's gansey sweaters, the Gansey Shawl uses traditional gansey patterns over a classic shawl shape in a worsted-weight yarn. This is a great pattern for those colder months when a lacy shawl won't do the trick. The result: a big, cozy shawl that's as functional as it is beautiful.

Finished Size
56" (142 cm) wide and 25½" (65 cm) long at center.

Yarn
Worsted weight (#4 Medium).

Shown here: The Fibre Co. Cumbria (90% wool, 10% mohair; 238 yd [218 m]/3½ oz [100 g]): #01 scaffel pike, 3 skeins.

Needles
Size U.S. 6 (4 mm): 60" (150 cm) circular (cir).
Adjust needle size if necessary to obtain the correct gauge.

Notions
Stitch markers (m); tapestry needle.

Gauge
16 sts and 33 rows = 4" (10 cm) in chart patt, blocked.

Notes
This shawl is worked back and forth from the neck down, starting with a small number of stitches and increasing to the largest number of stitches.

When working from the charts, slip all markers as you come to them unless instructed otherwise.

Garter Tab

CO 3 sts.

Rows 1–6: Knit.

Row 7: K3, do not turn work, but rotate it one-quarter turn to the right, then pick up and knit 3 sts along the left side edge (1 st in each garter ridge). Turn the work another quarter turn to the right and pick up and knit 3 sts (1 st in each loop) from CO edge—9 sts total.

Row 8: K3, p3, k3.

Set-up row: (RS) K3, m1l, k1, m1l, k1, m1r, k1, m1r, k3—13 sts.

Next row: (WS) K3, p3, k1, p3, k3.

Work Rows 1–8 or foll Set-Up Chart (all charts are on page 49).

Row 1: (RS) K4, place marker (pm), m1l, k1, m1r, pm, k3, pm, m1l, k1, m1r, pm, k4—17 sts.

Row 2: (WS) [K3, p1] twice, k1, [p1, k3] twice.

Row 3: [Knit to m, sl m, m1r, k3, m1l, sl m] twice, knit to end—21 sts.

Row 4: K3, p1, k5, p1, k1, p1, k5, p1, k3.

Row 5: [Knit to m, sl m, m1r, k5, k1l, sl m] twice, knit to end—25 sts.

Row 6: K3, p1, k7, p1, k1, p1, k7, p1, k3.

Row 7: [Knit to m, sl m, m1r, k7, m1l, sl m] twice, knit to end—29 sts.

Row 8: K3, p1, k9, p1, k1, p1, k9, p1, k3.

Body

Work Rows 1–12 or foll Chart A:

Row 1: (RS) K4, sl m, m1r, knit to 1 st before m, k1, m1l, sl m, k3, sl m, m1r, k1, knit to m, m1l, sl m, knit to end—4 sts inc'd.

Row 2: (WS) K3, p2, [k2, p2] to 2 sts before m, k2, p1, k1, p1, k2, [p2, k2] to 1 st before m, p2, k3.

Row 3: K4, sl m, m1r, k1, [p2, k2] to 2 sts before m, p2, m1l, sl m, k3, sl m, m1r, p2, [k2, p2] to 1 st before m, k1, m1l, sl m, knit to end—4 sts inc'd.

Row 4: K3, p1, k2, [p2, k2] to 3 sts before m, p2, [k1, p1] twice, k1, p2, [k2, p2] to 2 sts before m, k2, p1, k3.

Row 5: K4, sl m, m1r, p2, [k2, p2] to 3 sts before m, k2, p1, m1p, sl m, k3, sl m, m1p, p1, k2, [p2, k2] to 2 sts before m, p2, m1l, sl m, k4—4 sts inc'd.

Row 6: K3, p1, k1, p2, [k2, p2] to m, p1, k1, p1, [k2, p2] to 3 sts before m, p2, k1, p1, k3.

Row 7: K4, sl m, m1p, p1, k2, [p2, k2] to m, m1l, sl m, k3, m1r, [k2, p2] to 3 sts before m, k2, p1, m1p, sl m, k4—4 sts inc'd.

Row 8: K3, purl to center 3 sts, p1, k1, p1, purl to last 3 sts, k3.

Row 9: [Knit to m, sl m, m1p, purl to next m, m1p, sl m] twice, knit to end—4 sts inc'd.

Row 10: K3, purl to center 3 sts, p1, k1, p1, purl to last 3 sts, k3.

Row 11: Rep Row 9—4 sts inc'd.

Row 12: Rep Row 10.

Work Rows 1–12 or foll Chart B:

Row 1: (RS) K4, sl m, m1p, k3, [k4, p4] to 2 sts before m, k2, m1l, sl m, k3, sl m, m1r, k2, [p4, k4] to 3 sts before m, p3, m1p, sl m, k4—4 sts inc'd.

Row 2: (WS) K3, p2, [k4, p4] to 6 sts before m, k4, p3, k1, p3, [k4, p4] to 5 sts before m, k4, p2, k3.

Row 3: K4, sl m, m1r, k2, k1 to 5 sts before m, p4, k1, m1l, sl m, k3, sl m, m1r, k1, [k4, p4] to 6 sts before m, p4, k2, m1l, sl m, k4—4 sts inc'd.

Row 4: K3, p1, [k4, p4] to 1 st before m, p2, k1, p2, [k4, p4] to m, p1, k3.

Row 5: K4, sl m, m1p, [k4, p4] to 1 st before m, p1, m1p, sl m, k3, sl m, m1p, p1, [k4, p4] to m, m1p, sl m, k4—4 sts inc'd.

Row 6: K3, p1, [k4, p4] to 3 sts before m, k3, p1, k1, p1, k3, [p4, k4] to m, p1, k3.

Row 7: K4, sl m, m1p, p3, [k4, p4] to m, m1l, sl m, k3, sl m, m1r, [p4, k4] to 3 sts before m, p3, m1p, sl m, k4—4 sts inc'd.

Row 8: K3, p1, k3, [p4, k4] to 1 sts before m, p3, k1, p3, [k4, p4] to 3 sts before m, k3, p1, k3.

Row 9: K4, sl m, m1r, knit to m, m1l, sl m, k3, sl m, m1r, knit to m, m1l, sl m, k4—4 sts inc'd.

Row 10: K3, p1, knit to m, p1, k1, p1, knit to m, p1, k3.

Row 11: Rep Row 9—4 sts inc'd.

Row 12: Rep Row 10.

Work Rows 1–14 or follow Chart C:

Row 1: (RS) K4, sl m, m1r, knit to m, m1l, sl m, k3, sl m, m1r, knit to m, m1l, sl m, k4—4 sts inc'd.

Row 2: (WS) K3, p1, k2, [p1, k7] to 1 st before m, p2, k1, p2, [k7, p1] to 2 sts before m, k2, p1, k3.

Row 3: K4, sl m, m1p, p1, [k3, p5] to 2 sts before m, k2, m1l, sl m, k3, sl m, m1r, k2, [p5, k3] to 1 st before m, p1, m1p, sl m, k4—4 sts inc'd.

Row 4: K3, p1, k1, [p5, k3] to 4 sts before m, p5, k1, p5, [k3, p5] to 1 st before m, k1, p1, k3.

Row 5: K4, sl m, m1r, [k7, p1] to 5 sts before m, k5, m1l, sl m, k3, sl m, m1r, k5, [p1, k7] to m, m1l, sl m, k4—4 sts inc'd.

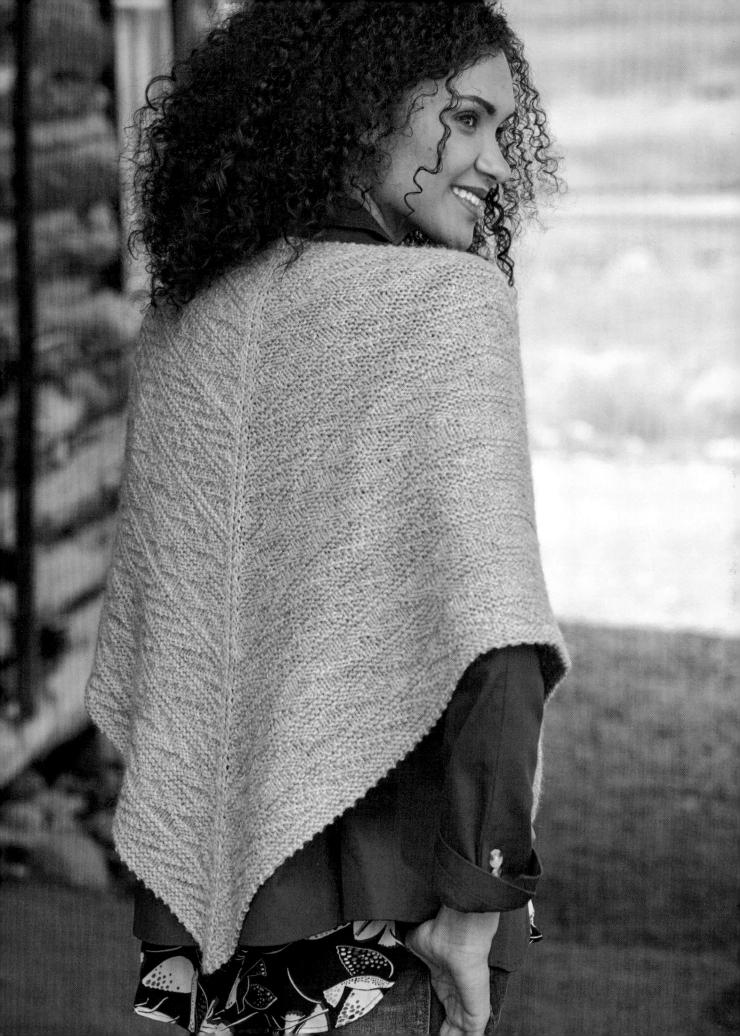

Steam Blocking

A garment steamer can be a great tool for a knitter. Unlike with wet blocking, items that are steam blocked dry much more quickly. This can be a big plus if you have limited space and can't leave a large item out drying for a whole day or two.

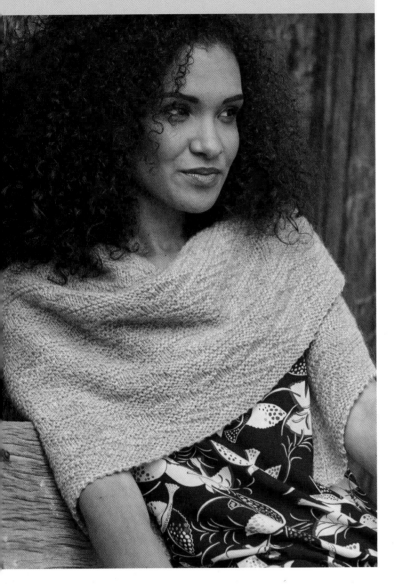

Row 6: K3, p2, [k7, p1] to 6 sts before m, k6, p1, k1, p1, k6, [p1, k7] to 1 st before m, p2, k3.

Row 7: K4, sl m, m1r, k2, [p5, k3] to 5 sts before m, p5, m1l, sl m, k3, sl m, m1r, [p5, k3] to 7 sts before m, p5, k2, m1l, sl m, k4—4 sts inc'd.

Row 8: K3, p5, [k3, p5] to 5 sts before m, k3, p3, k1, p3, [k3, p5] to 7 sts before m, k3, p5, k3.

Row 9: K4, sl m, m1r, k5, [p1, k7] to 4 sts before m, p1, k3, m1l, sl m, k3, sl m, m1r, k3, [p1, k7] to 6 sts before m, p1, k5, m1l, sl m, k4—4 sts inc'd.

Row 10: K3, purl to center 3 sts, p1, k1, p1, purl to last 3 sts, k3.

Row 11: K4, sl m, m1p, purl to m, m1p, sl m, knit to m, sl m, m1p, purl to m, m1p, sl m, k4—4 sts inc'd.

Rows 12–14: Rep Rows 10 and 11 once, then rep Row 10 once more—4 sts inc'd.

Work Rows 1–10 or follow Chart D:

Row 1: (RS) K4, sl m, m1p, k2, [p2, k2] to 1 st before m, p1, m1p, sl m, k3, sl m, m1p, p1, [k2, p2] to 2 sts before m, k2, m1p, sl m, k4—4 sts inc'd.

Row 2: (WS) K3, p3, [k2, p2] to 3 sts before m, k2, p2, k1, p2, [k2, p2] to m, p1, k3.

Row 3: K4, sl m, m1r, k1, [p2, k2] to m, m1p, sl m, k3, sl m, m1p, [k2, p2] to 1 st before m, k1, m1l, sl m, k4—4 sts inc'd.

Row 4: K3, [p2, k2] to m, p1, k1, p1, [k2, p2] to last 3 sts, k3.

Row 5: K4, sl m, m1r, [p2, k2] to 3 sts before m, p2, k1, m1l, sl m, k3, sl m, m1r, k1, [p2, k2] to 2 sts before m, p2, m1l, sl m, k4—4 sts inc'd.

Row 6: K3, p1, [k2, p2] to 1 st before m, [k1, p1] twice, k1, [p2, k2] to m, p1, k3.

Row 7: [K to m, sl m, m1r, knit to m, m1l, sl m] twice, k4—4 sts inc'd.

Row 8: K3, p1, knit to m, p1, k1, p1, knit to m, p1, k3.

Row 9: Rep Row 7—4 sts inc'd.

Row 10: Rep Row 8.

Work Charts A, B, C, and D 2 more times—317 sts.

Edging

Row 1: (RS) K4, sl m, m1r, knit to m, m1l, sl m, k3, sl m, m1r, knit to m, m1l, sl m, k4—321 sts.

Row 2: K3, p1, sl m, knit to m, sl m, p1, k1, p1, sl m, knit to m, sl m, p1, k3.

BO all sts using Channel Island bind-off (see Glossary). Fasten off last st.

Finishing

Weave in ends. Wet-block to finished measurements.

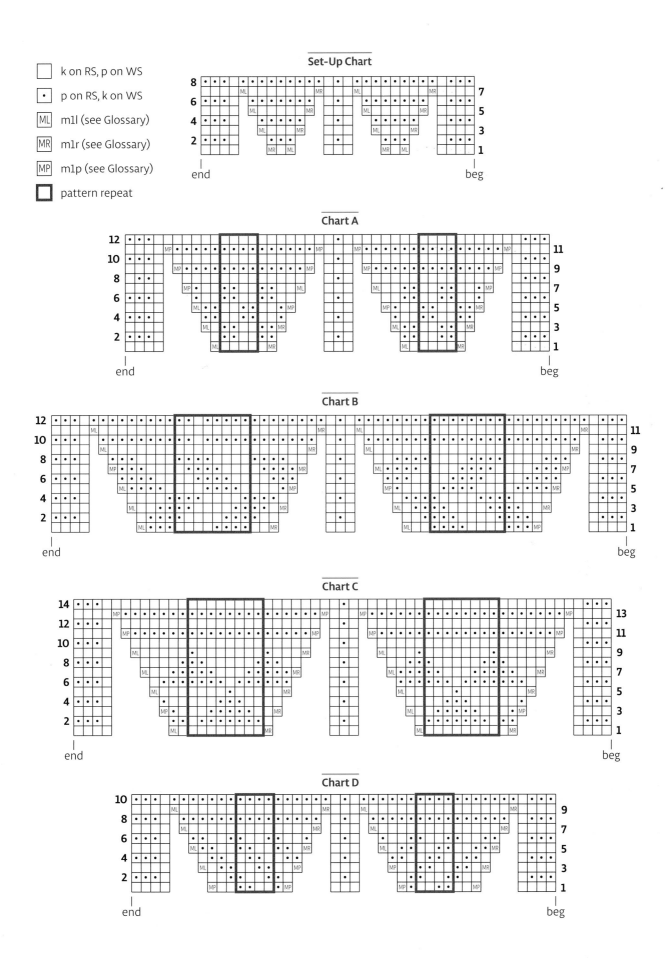

Set-Up Chart

Chart A

Chart B

Chart C

Chart D

k on RS, p on WS

· p on RS, k on WS

ML m1l (see Glossary)

MR m1r (see Glossary)

MP m1p (see Glossary)

pattern repeat

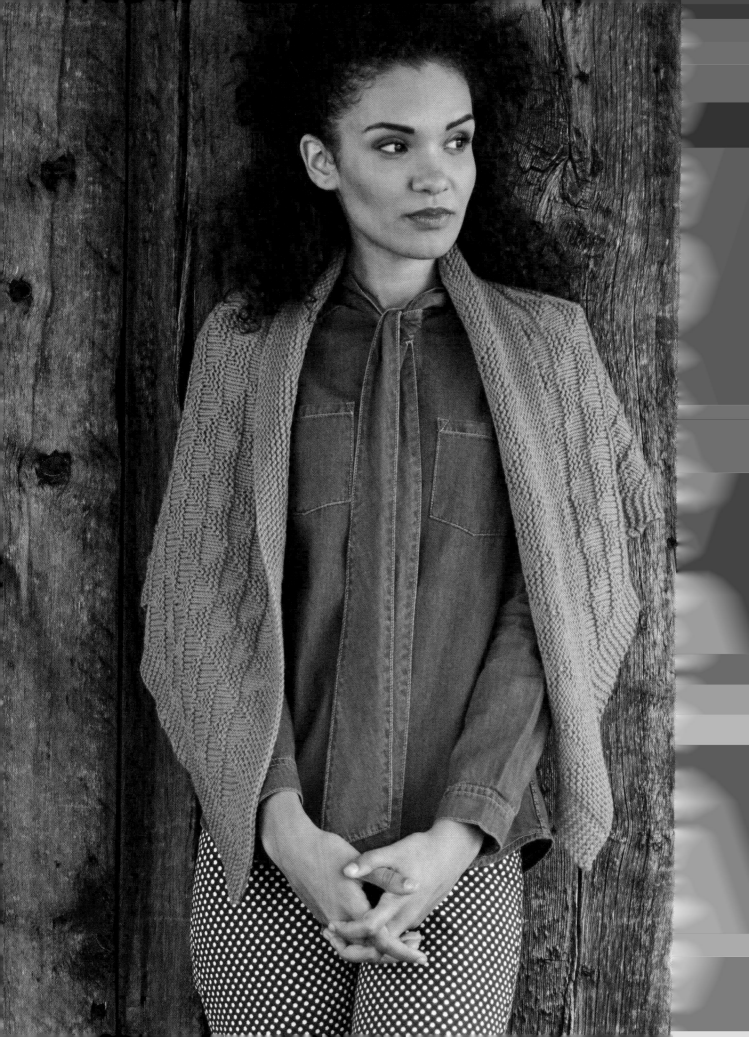

Designed by Leah B. Thibault

Fireside Shawl

This generously sized, simple-textured shawl features triangles upon triangles upon triangles. Garter-stitch borders combined with the knit-heavy stitch pattern mean that purling is limited, and the 8-row pattern repeat is easily memorized. Worked in a springy worsted-weight yarn, this shawl is a quick and cozy knit, perfect for curling up on a sofa or by a fire.

Finished Size
59" (150 cm) wide and 30" (76 cm) long.

Yarn
Worsted weight (#4 Medium).

Shown here: Spud and Chloë Sweater (55% wool, 45% organic cotton; 160 yd [146 m]/3½ oz [100 g]): #7515 cider, 5 skeins.

Gauge
14½ sts and 28 rows = 4" (10 cm) in patt.

Needles
Size U.S. 8 (5 mm): 36" (90 cm) or longer circular (cir). *Adjust needle size if necessary to obtain the correct gauge.*

Notions
Stitch markers (m); tapestry needle.

Notes
Shawl is worked from the point up. Two stitches are increased every wrong-side row, alongside a central spine for the border set-up, and alongside the inner side of the border thereafter.

To reduce the amount of purling required, all increases and patterning are worked on wrong-side rows. All right-side rows are knit even.

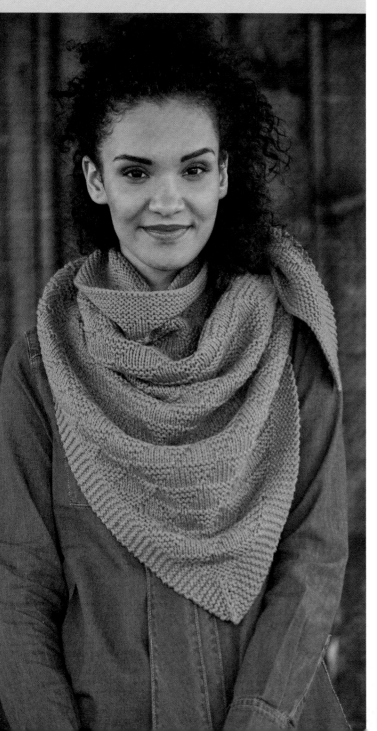

Stitch Guide

Pattern St (multiple of 8 sts + 3)

CO 27 sts for gauge swatch.

Row 1: (WS) K1, *p7, k1; rep from * to to last 3 sts, k1, p2.

Row 2 and all other RS rows: Knit.

Row 3: K2, *p5, k3; rep from * to last 9 sts, p5, k3, p1.

Row 5: K3, *p3, k5; rep from * to end.

Row 7: K4, *p1, k7; to last 7 sts, p1, k6.

Row 8: Knit.

Rep Rows 1–8 for Pattern St.

Set Up Border

CO 3 sts.

Row 1 and all other RS rows: Knit.

Row 2: (WS) K1, m1, p1, m1, k1—5 sts.

Row 4: K2, m1, p1, m1, k2—7 sts.

Row 6: K3, m1, p1, m1, k3—9 sts.

Row 8: K4, m1, p1, m1, k4—11 sts.

Row 10: K5, m1, p1, m1, k5—13 sts.

Row 12: K6, m1, p1, m1, k6—15 sts.

Row 13: K7, place marker (pm), k1, pm, knit to end.

Set Up Body

Row 1: (WS) Knit to m, sl m, m1, k1, m1, sl m, knit to end—17 sts.

Row 2: Knit to m, sl m, m1, k3, m1, sl m, knit to end—19 sts.

Row 3: Knit to m, sl m, m1, k5, m1, sl m, knit to end—21 sts.

Row 4: Knit to m, sl m, m1, k7, m1, sl m, knit to end—23 sts.

Row 5: Knit.

Body

Row 1: (WS) Knit to m, sl m, m1, k1, [p7, k1] to m, m1, sl m, knit to end—2 sts inc'd.

Row 2 and all other RS rows: Knit.

Row 3: Knit to m, sl m, m1, k3, [p5, k3] to m, m1, sl m, knit to end—2 sts inc'd.

Row 5: Knit to m, sl m, m1, k5, [p3, k5] to m, m1, sl m, knit to end—2 sts inc'd.

Row 7: Knit to m, sl m, m1, k7, [p1, k7] to m, m1, sl m, knit to end—2 sts inc'd.

Row 8: Knit.

Rep Rows 1–8 twenty-three more times—215 sts.

Top Border

Row 1: Knit to m, m1, sl m, knit to m, m1, sl m, knit to end—2 sts inc'd.

Row 2: Knit.

Rep last 2 rows 5 more times—227 sts.

BO all sts kwise.

Finishing

Weave in ends. Block to finished measurements.

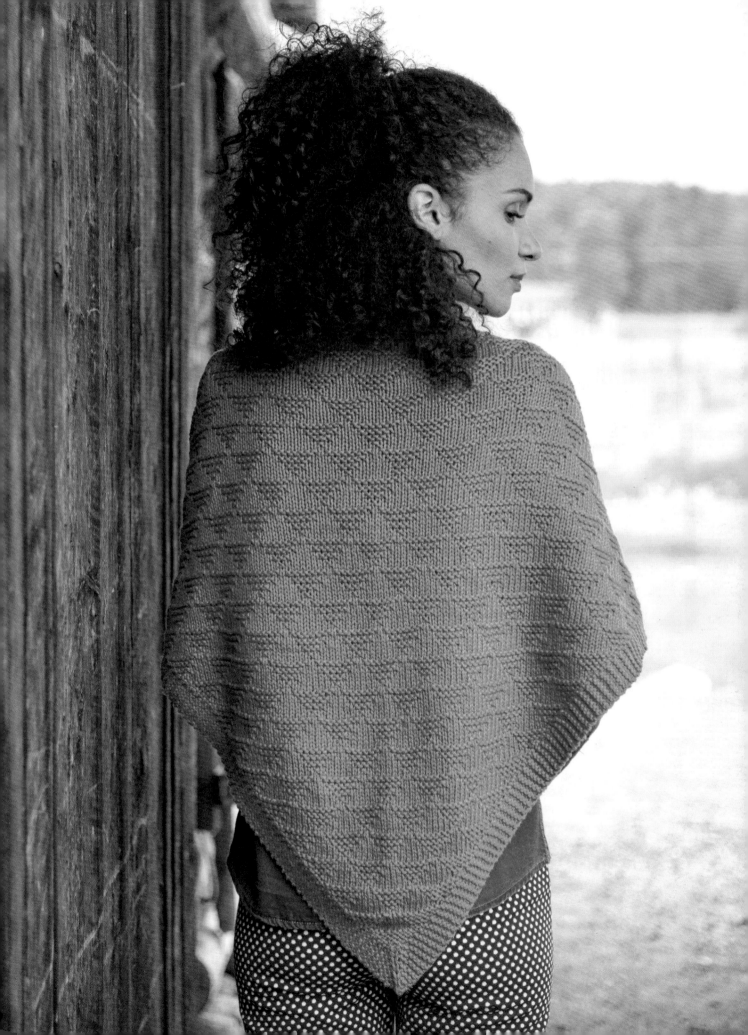

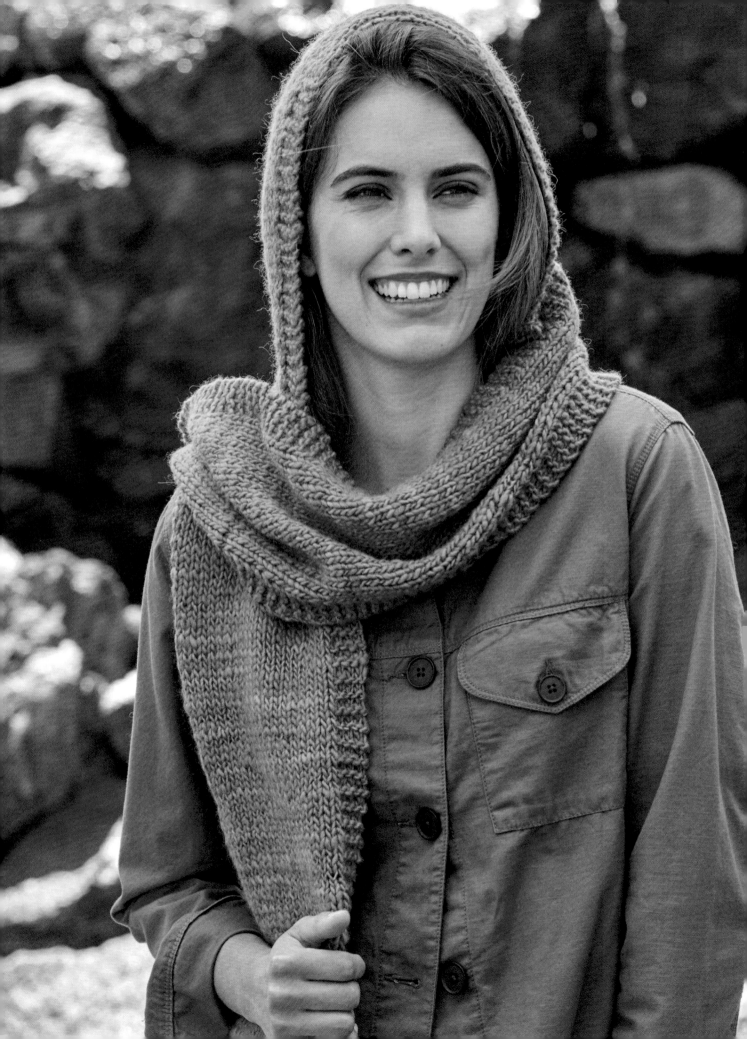

Wrapped in Wool

Everyone loves a good scarf, but they really add only a little warmth to a small area. The designers featured in this chapter went all out, creating generous wraps with cables, lace, and stripes and even a classic scarf with a smart twist—a cozy hood!

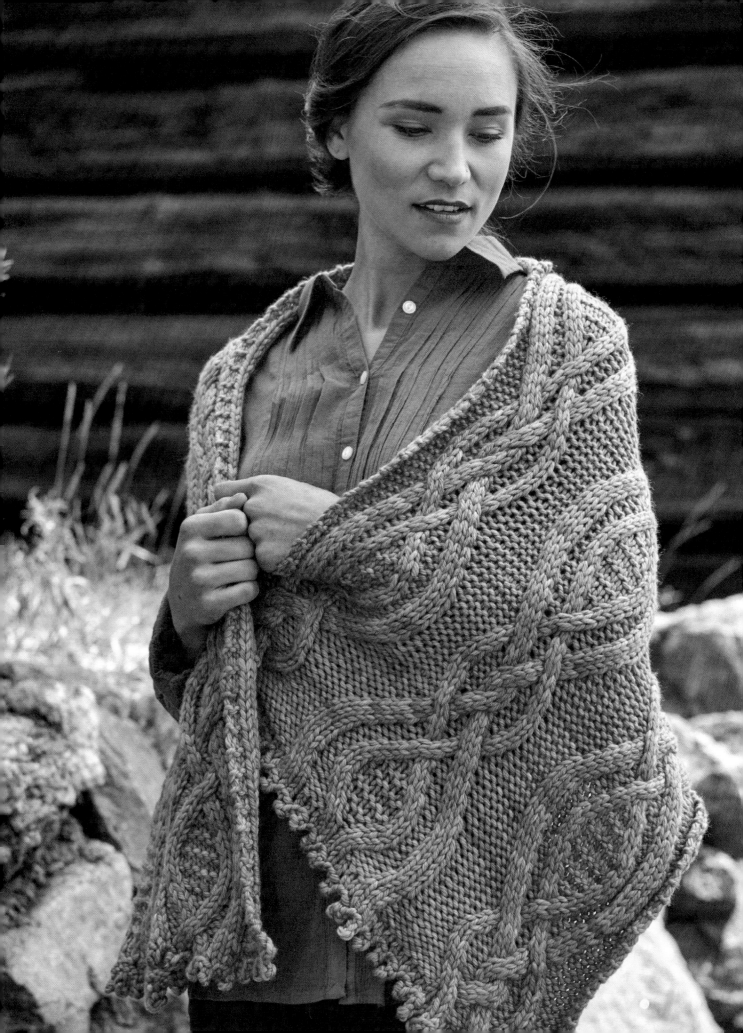

Designed by Tanis Gray

Caeruleus Wrap

This stunning sea-blue wrap features a beautiful all-over cable pattern that keeps the knitting interesting. Knit in a bulky yarn, it flies off the needles. A sweet picot bind-off gives it the perfect finishing touch.

Finished Size
19" (48.5 cm) wide and 55½" (141 cm) long.

Yarn
Bulky weight (#6 Super Bulky).

Shown here: Dragonfly Fibers Super Traveller (100% superwash merino wool; 107 yd [98 m]/4 oz [113 g]): forget-me-knot, 6 hanks.

Needles
Size U.S. 11 (8 mm): 24" (60 cm) circular (cir). *Adjust needle size if necessary to obtain the correct gauge.*

Notions
Cable needle (cn); waste yarn; size U.S. M-13 (9 mm) crochet hook; tapestry needle.

Gauge
15 sts and 14 rows = 4" (10 cm) in cable patt, blocked.

Note
If you want to make the wrap longer, you will need to purchase additional yarn.

Stitch Guide

2/1LPC (2 over 1 left purl cross): Sl 2 sts onto cn and hold in front of work, p1, k2 from cn.

2/1RPC (2 over 1 right purl cross): Sl 1 st onto cn and hold in back of work, k2, p1 from cn.

2/2RC (2 over 2 right cross): Sl 2 sts onto cn and hold in back of work, k2, k2 from cn.

2/3LC (2 over 3 left cross): Sl 2 sts onto cn and hold in front of work, k3, k2 from cn.

3/1LPC (3 over 1 left purl cross): Sl 3 sts onto cn and hold in front of work, p1, k3 from cn.

3/1RPC (3 over 1 right purl cross): Sl 1 st onto cn and hold in back of work, k3, p1 from cn.

3/2LC (3 over 2 left cross): Sl 3 sts onto cn and hold in front of work, k2, k3 from cn.

3/3RC (3 over 3 right cross): Sl 3 sts onto cn and hold in back of work, k3, k3 from cn.

Picot Bind-Off

*Cast on a new stitch by inserting right needle between first and second stitches on left needle and pulling up a loop. Place this new stitch on left needle tip. Cast on 1 more stitch in the same way. Bind off 4 stitches, place remaining stitch back on left needle tip. Repeat from * until all stitches are bound off.

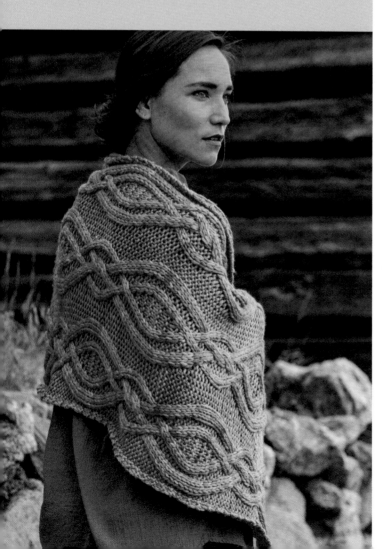

Wrap

With crochet hook and waste yarn, CO 72 sts using provisional method (see Glossary).

Knit 1 row.

Purl 1 row.

Work Rows 1–36 of cable patt or foll chart five times, or to desired length:

Cable Pattern

Row 1: (RS) K2, p5, 3/1RPC (see Stitch Guide), 2/1LPC (see Stitch Guide), 2/1RPC (see Stitch Guide), 3/1LPC (see Stitch Guide), p7, 3/1LPC, p2, 2/2RC (see Stitch Guide), p2, 3/1RPC, p7, 3/1RPC, 2/1LPC, 2/1RPC, 3/1LPC, p5, k2.

Row 2: (WS) K7, p3, k2, p4, k2, p3, k8, p3, k2, p4, k2, p3, k8, p3, k2, p4, k2, p3, k7.

Row 3: K2, p4, 3/1RPC, p2, 2/2RC, p2, 3/1LPC, p7, 3/1LPC, 2/1RPC, 2/1LPC, 3/1RPC, p7, 3/1RPC, p2, 2/2RC, p2, 3/1LPC, p4, k2.

Row 4: K6, p3, k3, p4, k3, p3, k8, p5, k2, p5, k8, p3, k3, p4, k3, p3, k6.

Row 5: K2, p3, 3/1RPC, p2, 2/1RPC, 2/1LPC, p2, 3/1LPC, p7, 3/2LC (see Stitch Guide), p2, 2/3LC (see Stitch Guide), p7, 3/1RPC, p2, 2/1RPC, 2/1LPC, p2, 3/1LPC, p3, k2.

Row 6: K5, p3, k3, p6, k3, p3, k7, p5, k2, p5, k7, p3, k3, p6, k3, p3, k5.

Row 7: K2, p2, 3/1RPC, p2, 2/1RPC, p2, 2/1LPC, p2, 3/1LPC, p5, 2/1RPC, 3/1LPC, 3/1RPC, 2/1LPC, p5, 3/1RPC, p2, 2/1RPC, p2, 2/1LPC, p2, 3/1LPC, p2, k2.

Row 8: K4, p3, k3, p8, k3, p3, k5, p2, k2, p6, k2, p2, k5, p3, k3, p8, k3, p3, k4.

Row 9: K2, p2, k3, p2, 2/1RPC, p4, 2/1LPC, p2, k3, p4, 2/1RPC, p2, 3/3RC (see Stitch Guide), p2, 2/1LPC, p4, k3, p2, 2/1RPC, p4, 2/1LPC, p2, k3, p2, k2.

Row 10: K4, p3, k2, p10, k2, p3, k4, p2, k3, p6, k3, p2, k4, p3, k2, p10, k2, p3, k4.

Row 11: K2, p2, k3, p2, k2, p6, k2, p2, k3, p4, k2, p3, k6, p3, k2, p4, k3, p2, k2, p6, k2, p2, k3, p2, k2.

Row 12: Rep Row 10.

Row 13: K2, p2, k3, p2, 2/1LPC, p4, 2/1RPC, p2, k3, p4, 2/1LPC, p2, 3/3RC, p2, 2/1RPC, p4, k3, p2, 2/1LPC, p4, 2/1RPC, p2, k3, p2, k2.

Row 14: K4, p3, k3, p8, k3, p3, k5, p2, k2, p6, k2, p2, k5, p3, k3, p8, k3, p3, k4.

Row 15: K2, p2, 3/1LPC, p2, 2/1LPC, p2, 2/1RPC, p2, 3/1RPC, p5, 2/1LPC, 3/1RPC, 3/1RPC, 2/1RPC, p5, 3/1LPC, p2, 2/1LPC, p2, 2/1RPC, p2, 3/1RPC, p2, k2.

Row 16: K5, p3, k3, p6, k3, p3, k7, p5, k2, p5, k7, p3, k3, p6, k3, p3, k5.

Cable Chart

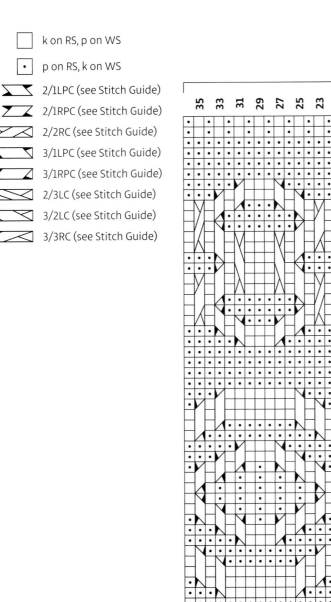

k on RS, p on WS

p on RS, k on WS

2/1LPC (see Stitch Guide)

2/1RPC (see Stitch Guide)

2/2RC (see Stitch Guide)

3/1LPC (see Stitch Guide)

3/1RPC (see Stitch Guide)

2/3LC (see Stitch Guide)

3/2LC (see Stitch Guide)

3/3RC (see Stitch Guide)

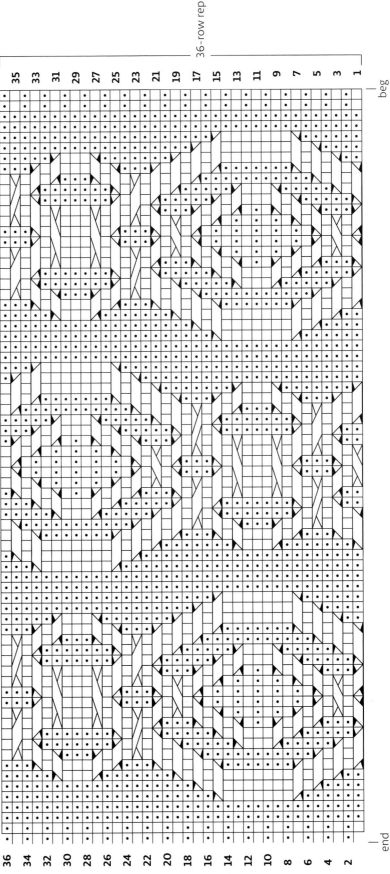

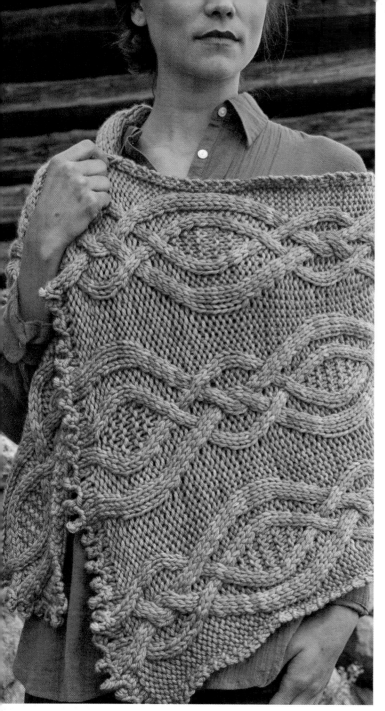

Row 22: K8, p5, k2, p5, k8, p3, k3, p4, k3, p3, k8, p5, k2, p5, k8.

Row 23: K2, p6, 3/2LC, p2, 2/3LC, p7, 3/1RPC, p2, 2/1RPC, 2/1LPC, p2, 3/1LPC, p7, 3/2LC, p2, 2/3LC, p6, k2.

Row 24: K8, p5, k2, p5, k7, p3, k3, p6, k3, p3, k7, p5, k2, p5, k8.

Row 25: K2, p5, 2/1RPC, 3/1LPC, 3/1RPC, 2/1LPC, p5, 3/1RPC, p2, 2/1RPC, p2, 2/1LPC, p2, 3/1LPC, p5, 2/1RPC, 3/1LPC, 3/1RPC, 2/1LPC, p5, k2.

Row 26: K7, p2, k2, p6, k2, p2, k5, p3, k3, p8, k3, p3, k5, p2, k2, p6, k2, p2, k7.

Row 27: K2, p4, 2/1RPC, p2, 3/3RC, p2, 2/1LPC, p4, k3, p2, 2/1RPC, p4, 2/1LPC, p2, k3, p4, 2/1RPC, p2, 3/3RC, p2, 2/1LPC, p4, k2.

Row 28: K6, p2, k3, p6, k3, p2, k4, p3, k2, p10, k2, p3, k4, p2, k3, p6, k3, p2, k6.

Row 29: K2, p4, k2, p3, k6, p3, k2, p4, k3, p2, k2, p6, k2, p2, k3, p4, k2, p3, k6, p3, k2, p4, k2.

Row 30: Rep Row 28.

Row 31: K2, p4, 2/1LPC, p2, 3/3RC, p2, 2/1RPC, p4, k3, p2, 2/1LPC, p4, 2/1RPC, p2, k3, p4, 2/1LPC, p2, 3/3RC, p2, 2/1RPC, p4, k2.

Row 32: K7, p2, k2, p6, k2, p2, k5, p3, k3, p8, k3, p3, k5, p2, k2, p6, k2, p2, k7.

Row 33: K2, p5, 2/1LPC, 3/1RPC, 3/1LPC, 2/1RPC, p5, 3/1LPC, p2, 2/1LPC, p2, 2/1RPC, p2, 3/1RPC, p5, 2/1LPC, 3/1RPC, 3/1LPC, 2/1RPC, p5, k2.

Row 34: K8, p5, k2, p5, k7, p3, k3, p6, k3, p3, k7, p5, k2, p5, k8.

Row 35: K2, p6, 2/3LC, p2, 3/2LC, p7, 3/1LPC, p2, 2/1LPC, 2/1RPC, p2, 3/1RPC, p7, 2/3LC, p2, 3/2LC, p6, k2.

Row 36: K8, p5, k2, p5, k8, p3, k3, p4, k3, p3, k8, p5, k2, p5, k8.

Rep Rows 1–36 for patt.

Work cable patt Rows 1–36 five times, or to desired length.

Knit 1 row.

Purl 1 row.

BO all sts using Picot BO (see Stitch Guide).

Remove provisional CO and place 72 sts on needle.

With RS facing, join yarn and work Picot BO.

Finishing

Weave in all ends. Block to 19" (48.5 cm) wide and 60" (152.5 cm) long. Wrap will relax to finished measurements after blocking.

Row 17: K2, p3, 3/1LPC, p2, 2/1LPC, 2/1RPC, p2, 3/1RPC, p7, 2/3LC, p2, 3/2LC, p7, 3/1LPC, p2, 2/1LPC, 2/1RPC, p2, 3/1RPC, p3, k2.

Row 18: K6, p3, k3, p4, k3, p3, k8, p5, k2, p5, k8, p3, k3, p4, k3, p3, k6.

Row 19: K2, p4, 3/1LPC, p2, 2/2RC, p2, 3/1RPC, p7, 3/1RPC, 2/1LPC, 2/1RPC, 3/1LPC, p7, 3/1LPC, p2, 2/2RC, p2, 3/1RPC, p4, k2.

Row 20: K7, p3, k2, p4, k2, p3, k8, p3, k2, p4, k2, p3, k8, p3, k2, p4, k2, p3, k7.

Row 21: K2, p5, 3/1LPC, 2/1RPC, 2/1LPC, 3/1RPC, p7, 3/1RPC, p2, 2/2RC, p2, 3/1LPC, p7, 3/1LPC, 2/1RPC, 2/1LPC, 3/1RPC, p5, k2.

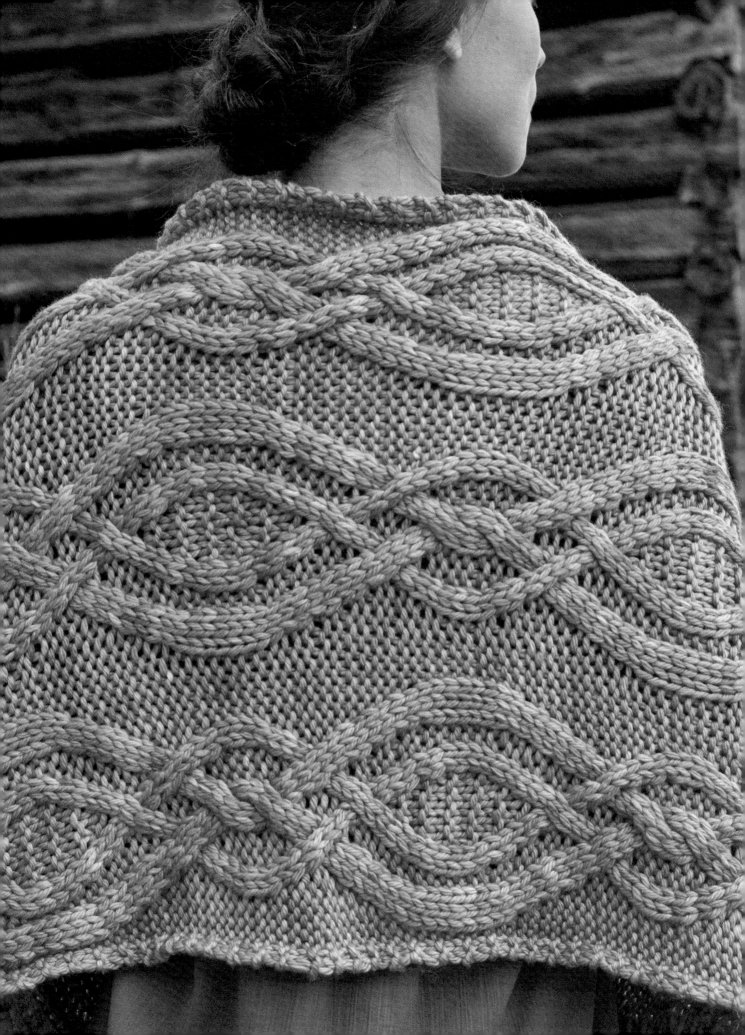

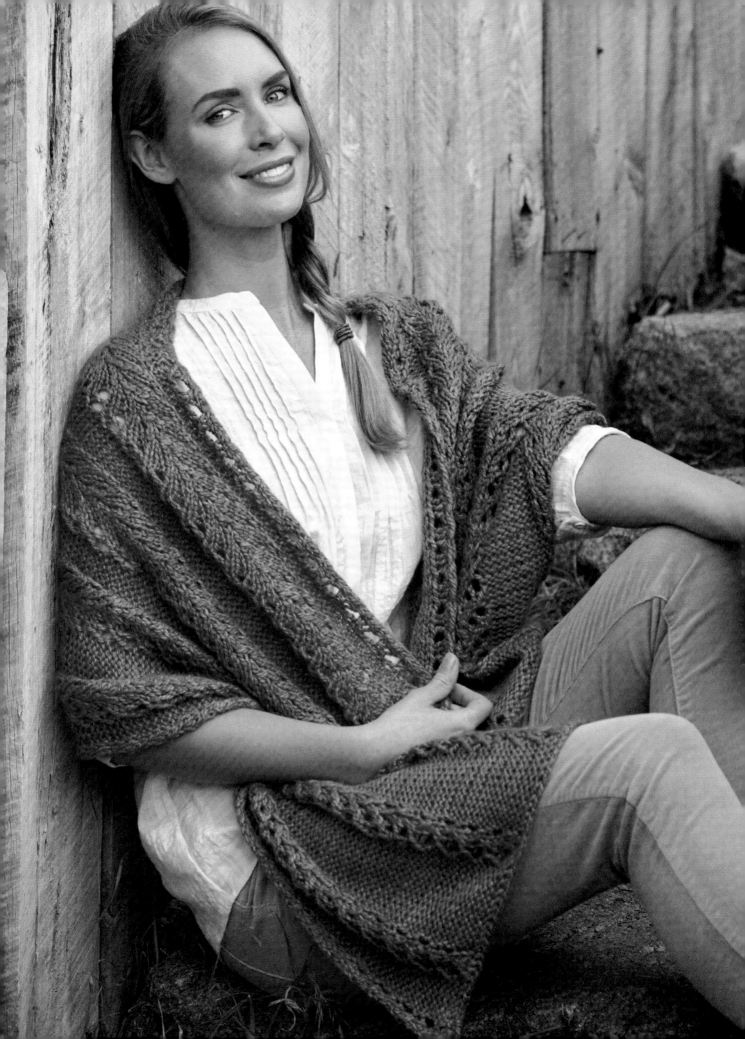

Designed by Bristol Ivy

Nonotuck Wrap

This generous wrap uses the classic stitch Vine Lace in an interesting way. The pattern is worked over a changing number of stitches, and the pattern shifts, creating lacy waves. Named for a mountain in Massachusetts popular for hiking, it mimics the meandering trails.

Finished Size
20½" (52 cm) wide and 67" (170 cm) long.

Yarn
Chunky weight (#5 Bulky).

The Fibre Co. Tundra (60% alpaca, 30% merino, 10% silk; 120 yd [110 m]/3½ oz [100 g]): taiga, 6 skeins.

Needles
Size U.S. 10 (6 mm): straight or 24" (60 cm) long circular (cir). *Adjust needle size if necessary to obtain the correct gauge.*

Notions
Stitch markers (m); tapestry needle.

Gauge
13½ sts and 16 rows = 4" (10 cm) in rev St st, blocked.

Notes
Wrap is worked from end to end; while the width of the wrap stays the same, the stitch patterns gradually grow and shrink along the length of the wrap.

Wrap

CO 66 sts using long-tail method (see Glossary). Do not join.

Set-up row: (WS) P3, place marker (pm), [k6, p3, k6, pm] 4 times, p3.

Body

Row 1: (RS) Working Row 1 of each chart (all charts are on page 67), work Edging Chart to m, sl m, [work Chart A to m, sl m] 4 times, work Edging Chart to end.

Rows 2–8: Work chart Rows 2–4, then work Rows 1–4 once more as established.

Row 9: (RS) Working Row 1 of each chart, work Edging Chart to m, sl m, work Chart B to next m, sl m, [work Chart A to next m, sl m] 3 times, work Edging Chart to end.

Row 10: (WS) Working Row 2 of each chart, work Edging Chart to m, sl m, [work Chart A to next m, sl m] 3 times, work Chart B to next m, sl m, work Edging Chart to end.

Rows 11–16: Work chart Rows 3 and 4, then work Rows 1–4 once more as established.

Row 17: (RS) Working Row 1 of each chart, work Edging Chart to m, sl m, [work Chart B to next m, sl m] 2 times, [work Chart A to next m, sl m] 2 times, work Edging Chart to end.

Row 18: (WS) Working Row 2 of each chart, work Edging Chart to m, sl m, [work Chart A to next m, sl m] 2 times, work Chart B to next m, sl m] 2 times, work Edging Chart to end.

Rows 19–24: Work chart Rows 3 and 4, then work Rows 1–4 once more as established.

Row 25: (RS) Working Row 1 of each chart, work Edging Chart to m, sl m, [work Chart B to next m, sl m] 3 times, work Chart A to next m, sl m, work Edging Chart to end.

Row 26: (WS) Working Row 2 of each chart, work Edging Chart to m, sl m, work Chart A to next m, sl m, [work Chart B to next m, sl m] 3 times, work Edging Chart to end.

Rows 27–32: Work chart Rows 3 and 4, then work Rows 1–4 once more as established.

Row 33: (RS) Working Row 1 of each chart, work Edging Chart to m, sl m, [work Chart B to next m, sl m] 4 times, work Edging Chart to end.

Row 34: (WS) Working Row 2 of each chart, work Edging Chart to m, sl m, [work Chart B to next m, sl m] 4 times, work Edging Chart to end.

Rows 35–40: Work chart Rows 3 and 4, then work Rows 1–4 once more as established.

Row 41: (RS) Working Row 1 of each chart, work Edging Chart to m, sl m, work Chart C to next m, sl m, [work Chart B to next m, sl m] 3 times, work Edging Chart to end.

Row 42: (WS) Working Row 2 of each chart, work Edging Chart to m, sl m, [work Chart B to next m, sl m] 3 times, work Chart C to next m, sl m, work Edging Chart to end.

Rows 43–48: Work chart Rows 3 and 4, then work Rows 1–4 once more as established.

Row 49: (RS) Working Row 1 of each chart, work Edging Chart to m, sl m, [work Chart C to next m, sl m] 2 times, [work Chart B to next m, sl m] 2 times, work Edging Chart to end.

Row 50: (WS) Working Row 2 of each chart, work Edging Chart to m, sl m, [work Chart B to next m, sl m] 2 times, [work Chart C to next m, sl m] 2 times, work Edging Chart to end.

Rows 51–56: Work chart Rows 3 and 4, then work Rows 1–4 once more as established.

Row 57: (RS) Working Row 1 of each chart, work Edging Chart to m, sl m, [work Chart C to next m, sl m] 3 times, work Chart B to next m, sl m, work Edging Chart to end.

Row 58: (WS) Working Row 2 of each chart, work Edging Chart to m, sl m, [work Chart B to next m, sl m, [work Chart C to next m, sl m] 3 times, work Edging Chart to end.

Rows 59–64: Work chart Rows 3 and 4, then work Rows 1–4 once more as established.

Row 65: (RS) Working Row 1 of each chart, work Edging Chart to m, sl m, [work Chart C to next m, sl m] 4 times, work Edging Chart to end.

Row 66: (WS) Working Row 2 of each chart, work Edging Chart to m, sl m, [work Chart C to next m, sl m] 4 times, work Edging Chart to end.

Rows 67–72: Work chart Rows 3 and 4, then work Rows 1–4 once more as established.

Row 73: (RS) Working Row 1 of each chart, work Edging Chart to m, sl m, work Chart D to next m, sl m, [work Chart C to next m, sl m] 3 times, work Edging Chart to end.

Row 74: (WS) Working Row 2 of each chart, work Edging Chart to m, sl m, [work Chart C to next m, sl m] 3 times, work Chart D to next m, sl m, work Edging Chart to end.

Rows 75–80: Work chart Rows 3 and 4, then work Rows 1–4 once more as established.

Row 81: (RS) Working Row 1 of each chart, work Edging Chart to m, sl m, [work Chart D to next m, sl m] 2 times, [work Chart C to next m, sl m] 2 times, work Edging Chart to end.

Row 82: (WS) Working Row 2 of each chart, work Edging Chart to m, sl m, [work Chart C to next m, sl m] 2 times, [work Chart D to next m, sl m] 2 times, work Edging Chart to end.

Rows 83–88: Work chart Rows 3 and 4, then work Rows 1–4 once more as established.

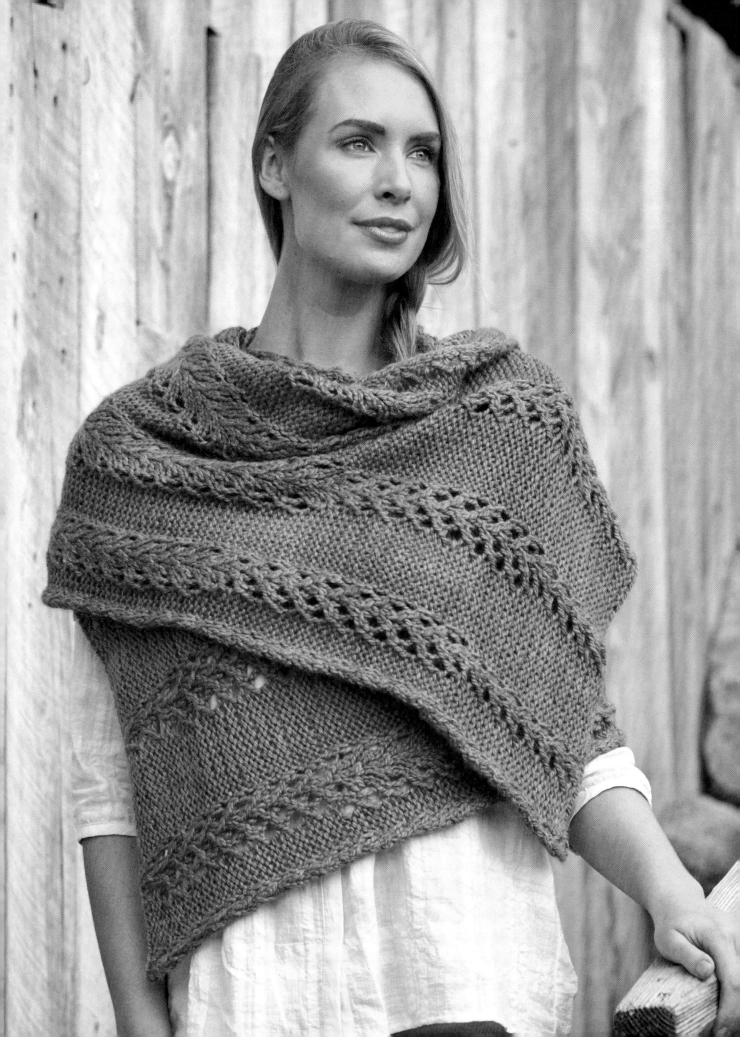

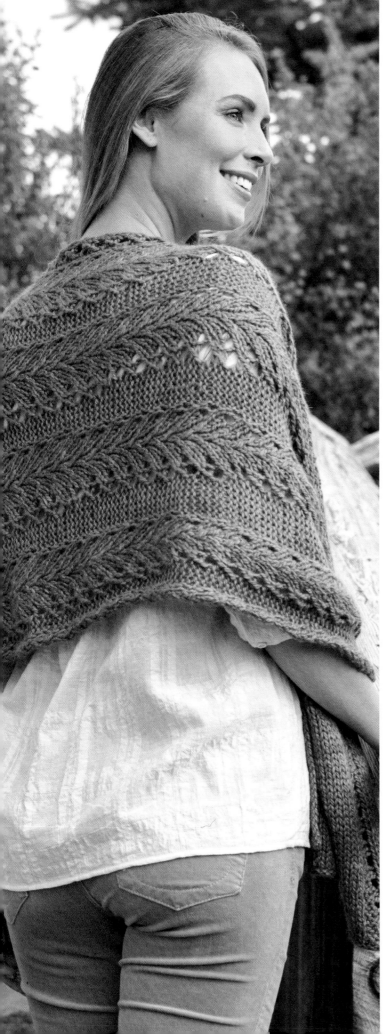

Row 89: (RS) Working Row 1 of each chart, work Edging Chart to m, sl m, [work Chart D to next m, sl m] 3 times, work Chart C to next m, sl m, work Edging Chart to end.

Row 90: (WS) Working Row 2 of each chart, work Edging Chart to m, sl m, work Chart C to next m, sl m, [work Chart D to next m, sl m] 3 times, work Edging Chart to end.

Rows 91–96: Work chart Rows 3 and 4, then work Rows 1–4 once more as established.

Row 97: (RS) Working Row 1 of each chart, work Edging Chart to m, sl m, [work Chart D to next m, sl m] 4 times, work Edging Chart to end.

Row 98: (WS) Working Row 2 of each chart, work Edging Chart to m, sl m, [work Chart D to next m, sl m] 4 times, work Edging Chart to end.

Rows 99–104: Work chart Rows 3 and 4, then work Rows 1–4 once more as established.

Row 105: (RS) Working Row 1 of each chart, work Edging Chart to m, sl m, work Chart E to next m, sl m, [work Chart D to next m, sl m] 3 times, work Edging Chart to end.

Row 106: (WS) Working Row 2 of each chart, work Edging Chart to m, sl m, [work Chart D to next m, sl m] 3 times, work Chart E to next m, sl m, work Edging Chart to end.

Rows 107–112: Work chart Rows 3 and 4, then work Rows 1–4 once more as established.

Row 113: (RS) Working Row 1 of each chart, work Edging Chart to m, sl m, [work Chart E to next m, sl m] 2 times, [work Chart D to next m, sl m] 2 times, work Edging Chart to end.

Row 114: (WS) Working Row 2 of each chart, work Edging Chart to m, sl m, [work Chart D to next m, sl m] 2 times, [work Chart E to next m, sl m] 2 times, work Edging Chart to end.

Rows 115–120: Work chart Rows 3 and 4, then work Rows 1–4 once more as established.

Row 121: (RS) Working Row 1 of each chart, work Edging Chart to m, sl m, [work Chart E to next m, sl m] 3 times, work Chart D to next m, sl m, work Edging Chart to end.

Row 122: (WS) Working Row 2 of each chart, work Edging Chart to m, sl m, work Chart D to next m, sl m, [work Chart E to next m, sl m] 3 times, work Edging Chart to end.

Rows 123–128: Work chart Rows 3 and 4, then work Rows 1–4 once more as established.

Row 129: (RS) Working Row 1 of each chart, work Edging Chart to m, sl m, [work Chart E to next m, sl m] 4 times, work Edging Chart to end.

Rows 130–136: Work chart Rows 2–4, then work Rows 1–4 once more as established.

Rows 137–144: Rep Rows 121–128.

Rows 145–152: Rep Rows 113–120.

Rows 153–160: Rep Rows 105–112.

Rows 161–168: Rep Rows 97–104.

Rows 169–176: Rep Rows 89–96.

Rows 177–184: Rep Rows 81–88.

Rows 185–192: Rep Rows 73–80.

Rows 193–200: Rep Rows 65–72.

Rows 201–208: Rep Rows 57–64.

Rows 209–216: Rep Rows 49–56.

Rows 217–224: Rep Rows 41–48.

Rows 225–232: Rep Rows 33–40.

Rows 233–240: Rep Rows 25–32.

Rows 241–248: Rep Rows 17–24.

Rows 249–256: Rep Rows 9–16.

Rows 257–264: Rep Rows 1–8.

BO all sts loosely.

Finishing

Weave in all ends. Block to finished measurements.

Chart A

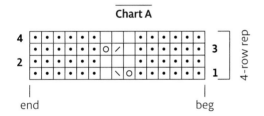

Chart B

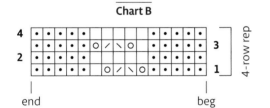

Chart C

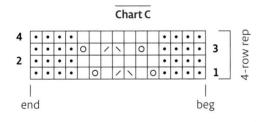

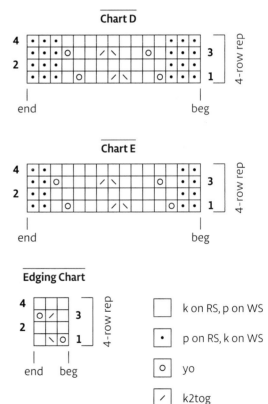

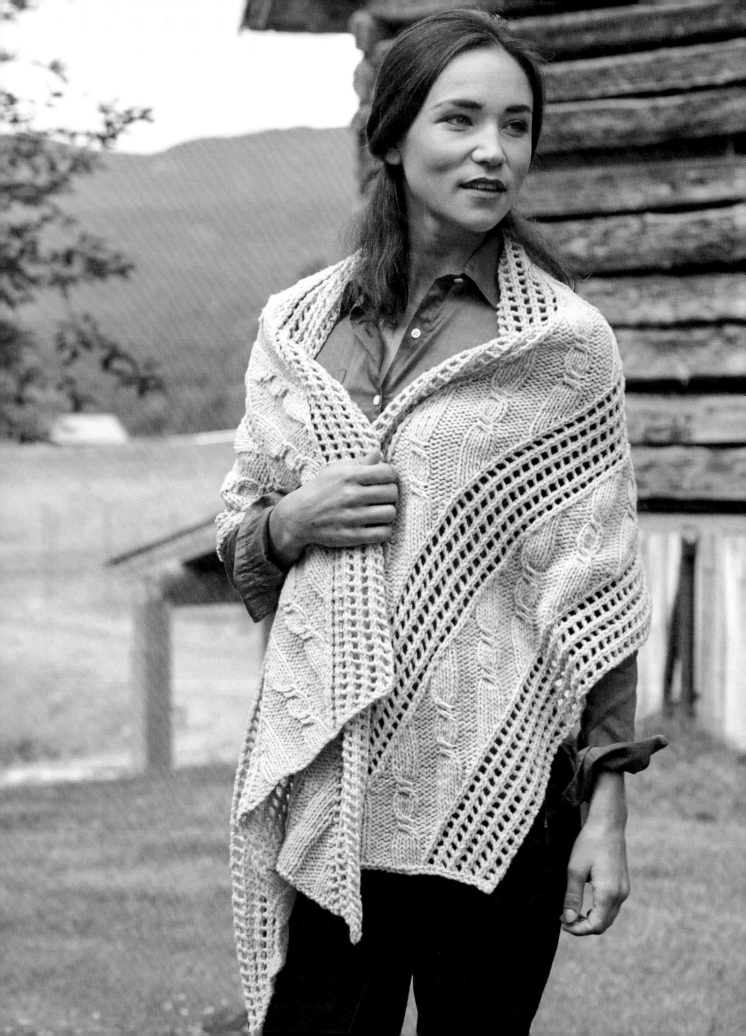

Designed by Leila Raabe

Bias Cable & Lace Stole

Diagonal lace mesh alternating between vertical cabled rib motifs that are worked on the bias creates an interesting result in the direction of the fabric. Knit in a chunky-weight yarn, this stole is lightweight, warm, and quick to work up, with a simple rhythm that is easily memorized after the first few repeats. Working the 2-stitch cables without a cable needle makes it fly off the needles even faster.

Finished Size
18" (45.5 cm) wide and 67" (170 cm) long along longest edge.

Yarn
Chunky weight (#5 Bulky).

Shown here: Brooklyn Tweed Quarry (100% wool; 200 yd [183 m]/3½ oz [100 g]): moonstone, 4 skeins.

Needles
Size U.S. 10½ (6.5 mm): straight or 24" (60 cm) long circular (cir). *Adjust needle size if necessary to obtain the correct gauge.*

Notions
Cable needle (cn); tapestry needle; blocking wires (optional, but recommended).

Gauge
13 sts and 20 rows = 4" (10 cm) in St st, blocked.

Note
Stole is knit on the bias, increasing one stitch at the beginning of every right-side row and decreasing one stitch at the end of the same row.

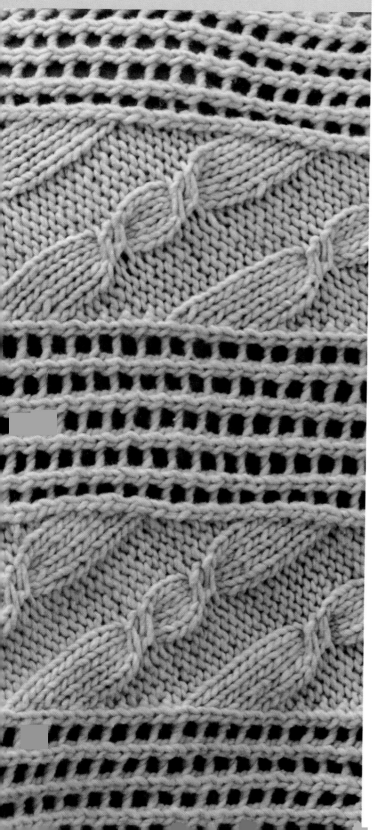

Stitch Guide

1/1RC (1 over 1 right cross): Sl 1 st onto cn and hold in back of work, k1, k1 from cn.

1/1RPC (1 over 1 right purl cross): Sl 1 st onto cn and hold in back of work, k1, p1 from cn.

1/3LC (1 over 3 left cross): Sl 1 st onto cn and hold in front of work, k3, k1 from cn.

Stole

CO 65 stitches using Cable method (see Glossary).

Set-Up Section
(also see Set-Up Section Chart on page 72)

Row 1: (RS) K1, [yo, k2tog] 4 times, yo, *1/1RC (see Stitch Guide), k3, p4, k4, p4, [k2tog, yo] 5 times; rep from * once more, k2tog.

Row 2: (WS) P11, *k4, p4, k4, p15; rep from * once more.

Row 3: K1, [yo, k2tog] 4 times, yo, *1/1RPC (see Stitch Guide), k4, p4, k4, p3, [k2tog, yo] 5 times; rep from * once more, k2tog.

Row 4: *P11, k3, p4, k4, p4, k1; rep from * once more, p11.

Row 5: K1, [yo, k2tog] 4 times, yo, *1/1RPC, p1, k4, p4, k4, p2, [k2tog, yo] 5 times; rep from * once more, k2tog.

Row 6: *P11, k2, p4, k4, p4, k2; rep from * once more, p11.

Row 7: K1, [yo, k2tog] 4 times, yo, *1/1RPC, p2, k4, p4, k4, p1, [k2tog, yo] 5 times; rep from * once more, k2tog.

Row 8: *P11, k1, p4, k4, p4, k3; rep from * once more, p11.

Main Section
(also see Main Section Chart on page 72)

Row 1: (RS) K1, [yo, k2tog] 4 times, yo, *1/1RPC, p3, 1/3LC (see Stitch Guide), p4, k4, [k2tog, yo] 5 times; rep from * once more, k2tog.

Row 2 (WS): *P15, k4, p4, k4; rep from * once more, p11.

Row 3: K1, [yo, k2tog] 4 times, yo, *1/1RC, p4, 1/3LC, p4, k3, [k2tog, yo] 5 times; rep from * once more, k2tog.

Row 4: P14, k4, p4, k4, p15, k4, p4, k4, p12.

Row 5: K1, [yo, k2tog] 4 times, yo, *1/1RC, k1, p4, k4, p4, k2, [k2tog, yo] 5 times; rep from * once more, k2tog.

Row 6: P13, k4, p4, k4, p15, k4, p4, k4, p13.

Row 7: K1, [yo, k2tog] 4 times, yo, *1/1RC, k2, p4, k4, p4, k1, [k2tog, yo] 5 times; rep from * once more, k2tog.

Row 8: P12, k4, p4, k4, p15, k4, p4, k4, p14.

Row 9: K1, [yo, k2tog] 4 times, yo, *1/1RC, k3, p4, 1/3LC, p4, [k2tog, yo] 5 times; rep from * once more, k2tog.

Row 10: P11, *k4, p4, k4, p15; rep from * once more.

Row 11: K1, [yo, k2tog] 4 times, yo, *1/1RPC, k4, p4, 1/3 LC, p3, [k2tog, yo] 5 times; rep from * once more, k2tog.

Row 12: *P11, k3, p4, k4, p4, k1; rep from * once more, p11.

Row 13: K1, [yo, k2tog] 4 times, yo, *1/1RPC, p1, k4, p4, k4, p2, [k2tog, yo] 5 times; rep from * once more, k2tog.

Row 14: *P11, k2, p4, k4, p4, k2; rep from * once more, p11.

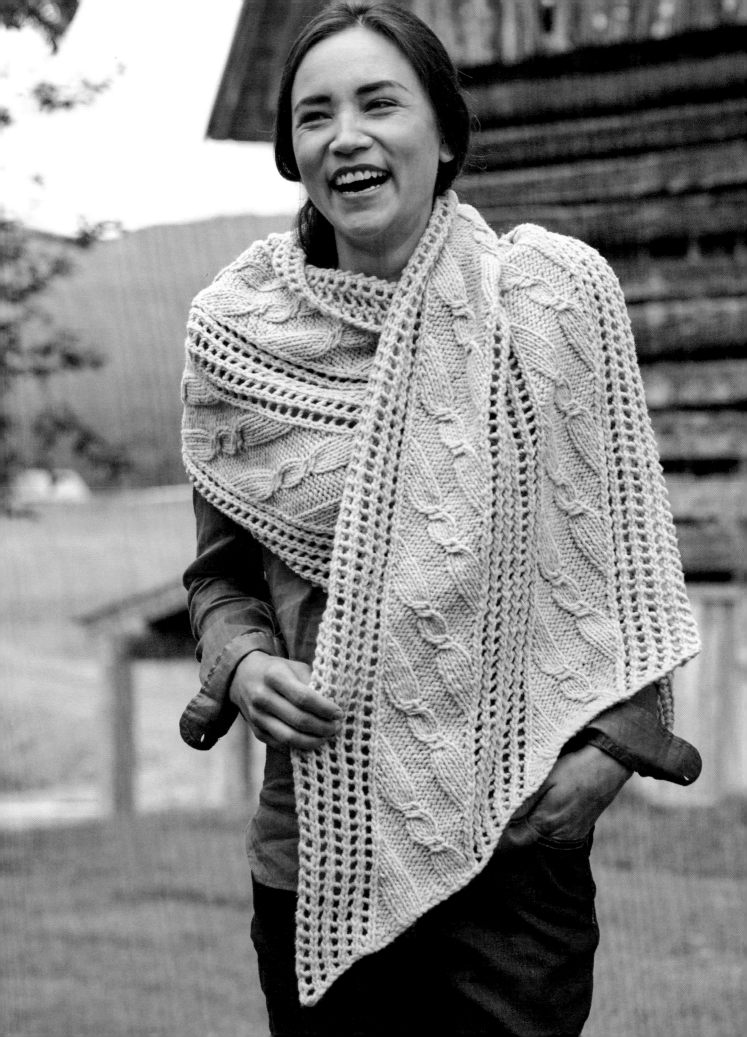

Row 15: K1, [yo, k2tog] 4 times, yo, *1/1RPC, p2, k4, p4, k4, p1, [k2tog, yo] 5 times; rep from * once more, k2tog.

Row 16: *P11, k1, p4, k4, p4, k3; rep from * once more, p11.

Rep Rows 1–16 of Main Section 16 more times.

Ending Section (also see Ending Section Chart)
Row 1: (RS) K1, [yo, k2tog] 4 times, yo, *1/1RPC, p3, k4, p4, k4, [k2tog, yo] 5 times; rep from * once more, k2tog.

Row 2: (WS) *P15, k4, p4, k4; rep from * once more, p11.

BO all sts kwise.

Finishing

Weave in ends. Block to 19" (48.5 cm) wide and 72" (183 cm) long along the longest edge, using T-pins and blocking wires if desired. Stole will relax to finished measurements after unpinning.

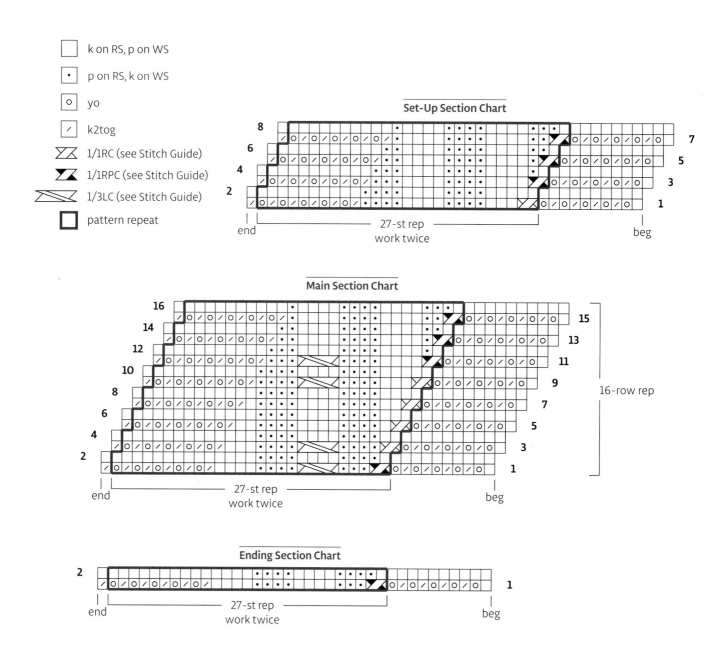

	k on RS, p on WS
	p on RS, k on WS
	yo
	k2tog
	1/1RC (see Stitch Guide)
	1/1RPC (see Stitch Guide)
	1/3LC (see Stitch Guide)
	pattern repeat

Set-Up Section Chart

27-st rep
work twice

Main Section Chart

27-st rep
work twice

16-row rep

Ending Section Chart

27-st rep
work twice

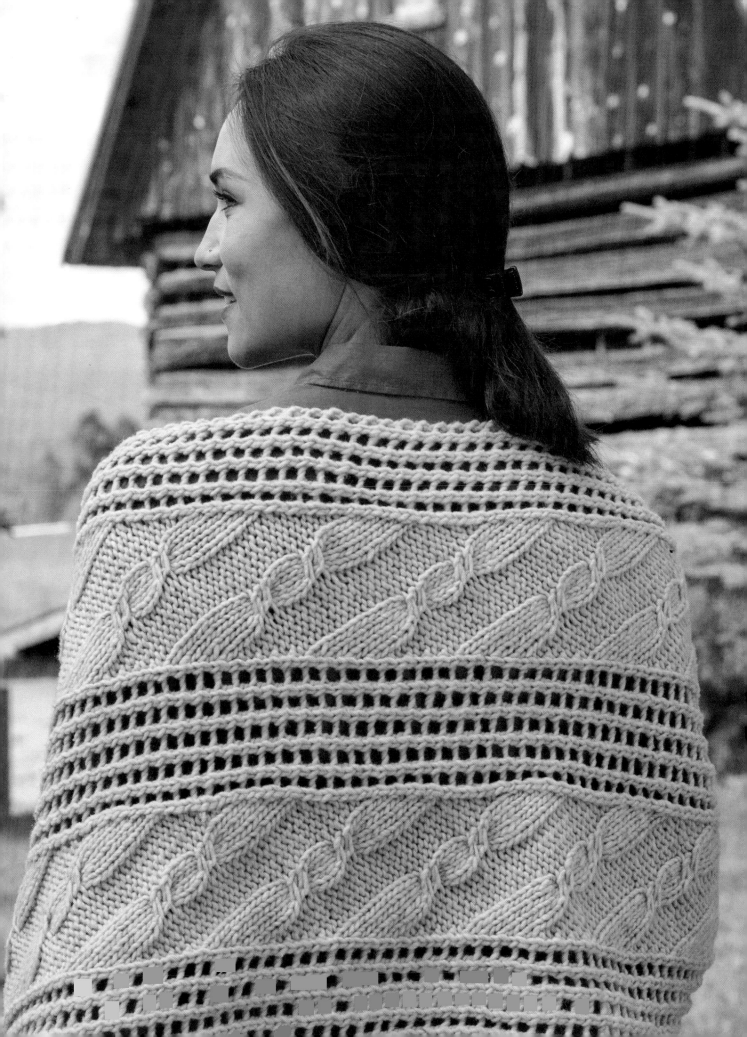

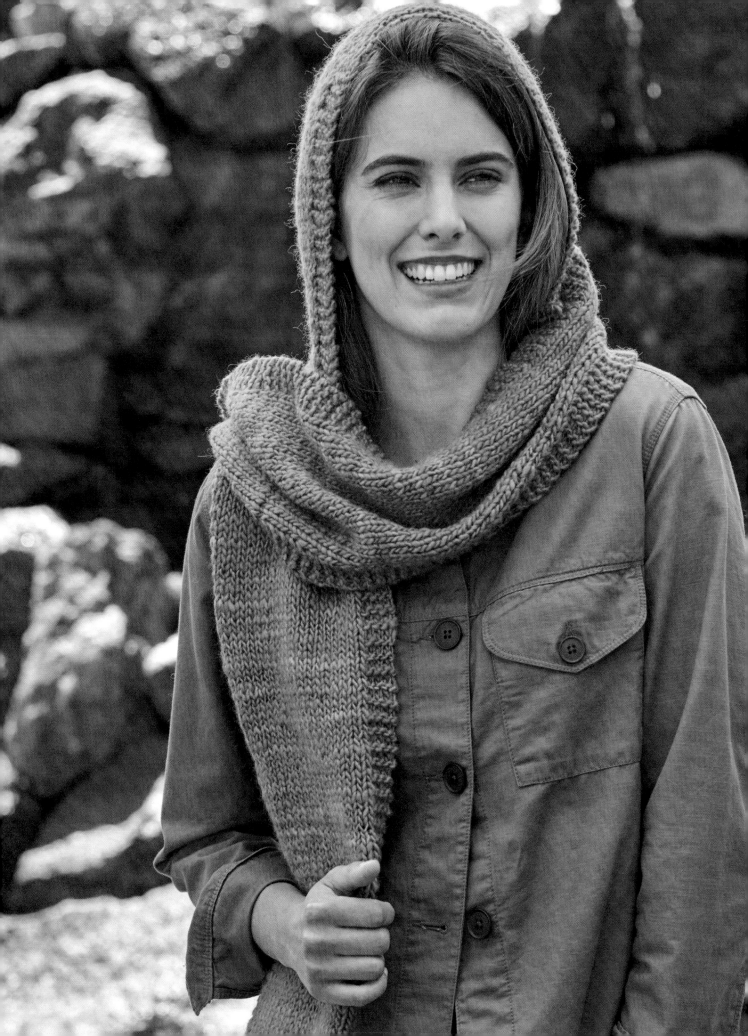

Designed by Kristen TenDyke

Highland Hooded Scarf

Scarves are great for keeping your neck and chest warm, but this scarf has something more! A hood is attached to the back, so you can add a little warmth to your head and ears, when you need to, and let it hang back when you don't.

Finished Size

Scarf: 8½" (21.5 cm) wide and 63½" (161.5 cm) long.

Hood: About 12" (30.5 cm) high and 8¾" (22 cm) deep.

Yarn

Aran weight (#4 Medium).

Shown here: Manos del Uruguay Wool Clasica (100% wool; 138 yd [126 m]/3½ oz [100 g]): #51 jade, 5 skeins.

Needles

Size U.S. 10½ (6.5 mm): straight and 24" (60 cm) circular (cir). *Adjust needle size if necessary to obtain the correct gauge.*

Notions

Stitch markers (m); tapestry needle.

Gauges

14 sts and 21½ rows = 4" (10 cm) in St st.

13 sts and 27 rows = 4" (10 cm) in garter st.

Notes

Scarf is worked first, from one end to the other, with a few stitches bound off, then cast on where the hood stitches will be picked up. Hood stitches are picked up at the center of the scarf, then knit. Markers are placed at the center back of the hood, and the hood is shaped with increases and short-rows to the top. At the top, the center back sts are worked back and forth in short-rows, decreasing the stitches to either side until only the center stitches remain.

Circular needle is used to accommodate large number of sts on hood.

Scarf

With straight needles, CO 29 sts.

Knit 8 rows, ending with a WS row.

Set-up row 1: (RS) Knit.

Set-up row 2: (WS) K4, purl to last 4 sts, k4.

Rep last 2 rows until piece measures 26" (66 cm) from beg, ending with a RS row. See Alternating Hand-dyed Yarns (page 77).

Center Garter Stitch

Knit 8 rows, ending with a RS row.

Next row: (WS) BO 6 sts, knit to end—23 sts rem.

Cont even in garter st (knit every row) for 59 rows, ending with a RS row. There will be 34 garter ridges on RS.

Next row: (WS) CO 6 sts using Cable method (see Glossary), knit to end—29 sts.

Cont even in garter st for 8 more rows, ending with a WS row.

Next row: (RS) Knit.

Next row: (WS) K4, purl to last 4 sts, k4.

Rep last 2 rows until piece measures 24¾" (63 cm) from center garter section, ending with a RS row.

Knit 8 rows, ending with a RS row.

BO all sts kwise.

Hood

With circular needle and RS facing, beg at CO sts of center garter section, pick up and knit 6 sts along CO sts (1 st in each CO st), 1 st at corner, 30 sts evenly along center garter section (1 st in each garter ridge), 1 st at corner, then 6 sts along BO sts (1 st in each BO st)—44 sts. Do not join; work back and forth in rows.

Set-up row (RS): Work 4 sts in garter st, work 11 sts in St st (knit on RS, purl on WS), place marker (pm), work 14 sts in garter st, pm, work 11 sts in St st, work 4 sts in garter st.

Shape Hood

Work 9 rows even in established patt, ending with a WS row.

Inc row: (RS) K5, m1l (see Glossary), knit to 1 st before m, m1r (see Glossary), k1, sl m, knit to next m, sl m, k1, m1l, knit to last 5 sts, m1r, k5—4 sts inc'd.

Rep last 10 rows 3 more times—60 sts; 14 center garter sts, and 23 sts on each side.

Cont even in established patt until piece measures 9" (23 cm) from pick-up row, ending with a WS row.

Raise Back of Hood

Short-row 1: Work in established patt to last 7 sts, wrap and turn (see short-rows in Glossary); work in established patt to last 7 sts, wrap and turn.

Short-row 2: Work to 5 sts before wrapped st on previous row, wrap and turn; work to 5 sts before wrapped st on previous row, wrap and turn.

Rep last short-row once more.

Next 2 rows: Work in established patt to end, hiding wraps.

Shape Top of Hood

Short-row 1: Knit to first m, remove m, k1, replace m, knit to 1 st before second m, sl 1 st, remove m, return slipped st to LH needle and replace m, k2tog, turn work without wrapping next st; k1, sl m, knit to next m, sl m, ssk, turn work without wrapping next st—58 sts; 12 garter sts between m, and 23 sts outside m on each side.

Short-row 2: K1, sl m, knit to next m, sl m, k2tog, turn work without wrapping next st; k1, sl m, knit to next m, sl m, ssk, turn work without wrapping next st—2 sts dec'd; 1 st from each side.

Rep last short-row 20 more times—16 sts rem; 12 garter sts between m, and 2 sts outside m on each side.

Next row: (RS) Sl 1 st pwise wyb, remove m, knit to next m, remove m, k2tog—15 sts rem.

BO row: (WS) BO all sts as foll: sl 1 pwise wyf, knit to last 2 sts, ssp.

Finishing

Weave in ends. Block to finished measurements.

Alternating Hand-dyed Yarns

When using hand-dyed yarns, colors may vary slightly between skeins, and it is recommended to alternate skeins every couple rows. Here's how to do this in a way that is not visible from the RS.

Note: Because there are no stitches picked up along the selvedge edge of the scarf, the point where the skeins alternate should be between the garter-stitch edge stitches and the main stockinette-stitch section, as follows.

Skein-change row: (RS) *Work 4 sts in garter st, drop yarn from working skein over the yarn from the new skein to the left and bring the yarn from the new skein up from below on the right, continue to end of row with the yarn from the new skein. Work 1 whole WS row with the yarn from the new skein. Repeat from * throughout.

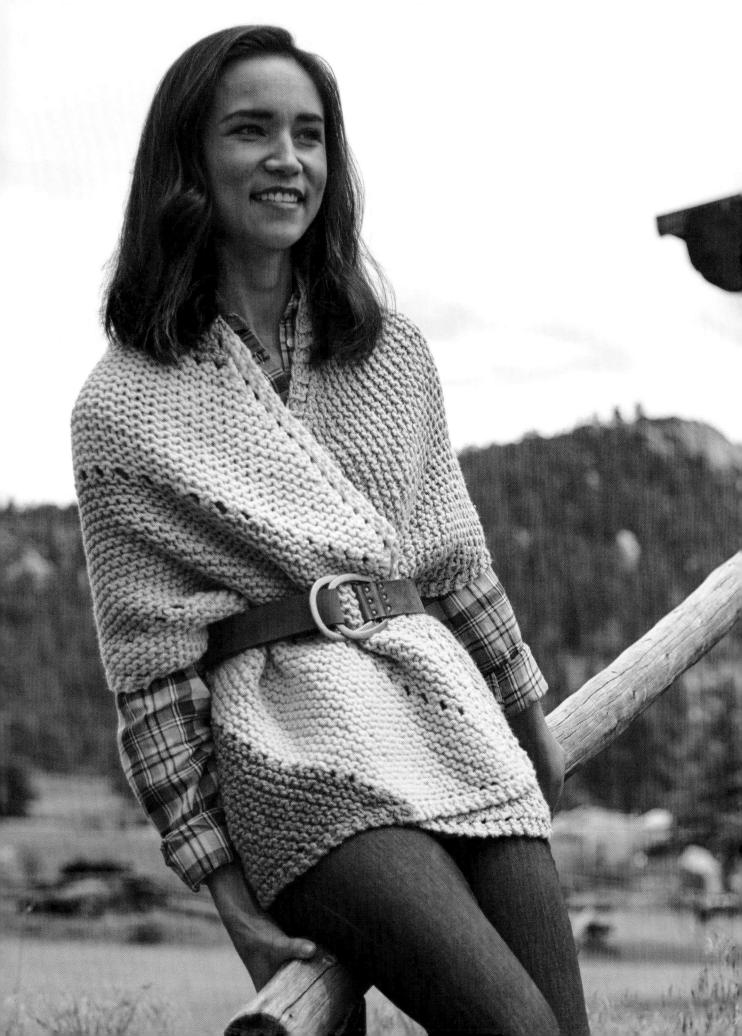

Designed by Jocelyn J. Tunney

North Winds Wrap

This bulky wrap is a fun way to play with color—and to stay snug when the cold winds blow! Knit from corner to corner, it creates a diagonal striping pattern on a wrap that's heavy enough to really keep you warm.

Finished Size
17" (43 cm) wide and 61" (155 cm) long.

Yarn
Chunky weight (#5 Bulky).

Shown here: O-Wool Balance Bulky (50% organic merino wool, 50% organic cotton; 106 yd [97 m]/3½ oz [100 g]): celestine (blue-green, A), 3 skeins; travertine (orange, B), 1 skein.

O-Wool Legacy Bulky (100% organic merino wool; 106 yd [97 m]/3½ oz [100 g]): desert blush (light pink, C); oyster mushroom (beige, D); raincloud (light blue-green, E), 1 skein each.

Needles
Size U.S. 13 (9 mm): 24" (60 cm) circular (cir). *Adjust needle size if necessary to obtain the correct gauge.*

Notions
Tapestry needle.

Gauge
9½ sts and 19 rows = 4" (10 cm) in garter st.

Stitch Guide

Increase Pattern

Row 1: K2, yo, knit to last 2 sts, yo, k2—2 sts inc'd.

Row 2: Knit.

Rep Rows 1 and 2 for Increase Patt.

Bias Pattern

Row 1: K2, yo, sssk, knit to last 2 sts, yo, k2.

Row 2: Knit.

Rep Rows 1 and 2 for Bias Patt.

Decrease Pattern

Row 1: K2, yo, sssk, knit to last 5 sts, k3tog, yo, k2—2 sts dec'd.

Rep Rows 1 and 2 for Decrease Patt.

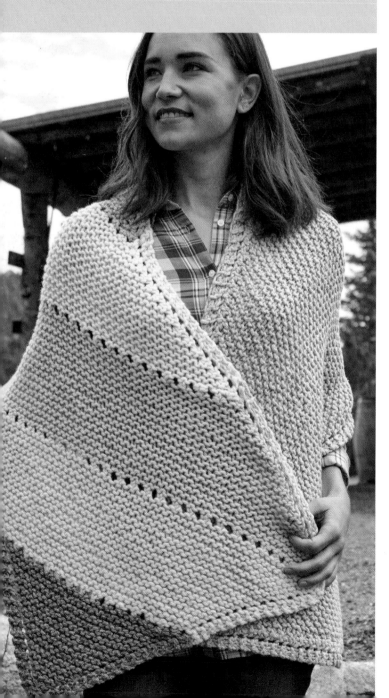

Wrap

With B, CO 1 st.

Row 1: (RS) K1f/b/f—3 sts.

Row 2: Knit.

Row 3: [K1, m1] twice, k1—5 sts.

Row 4: Knit.

Rows 5–32: Work Rows 1 and 2 of Inc Patt (see Stitch Guide) 14 times—33 sts.

Change to C.

Row 33: K2, yo, k1, *yo, k2tog; rep from * 14 times, yo, k2—35 sts.

Row 34: Knit.

Rows 35–64: Work Rows 1 and 2 of Inc Patt 15 times—65 sts.

Change to D.

Row 65: K2, yo, sssk, *yo, k2tog; rep from * 28 more times, yo, k2.

Row 66: Knit.

Rows 67–96: Work Rows 1 and 2 of Bias Patt (see Stitch Guide) 15 times.

Change to E.

Row 97: K2, yo, sssk, *yo, k2tog; rep from * 28 more times, yo, k2.

Row 98: Knit.

Rows 99–128: Work Rows 1 and 2 of Bias Patt 15 times.

Change to A.

Row 129: K2, yo, sssk, *yo, k2tog; rep from * 28 more times, yo, k2.

Row 130: Knit.

Rows 131–192: Work Rows 1 and 2 of Bias Patt 30 times.

Rows 193–248: Work Rows 1 and 2 of Dec Patt (see Stitch Guide) 28 times—9 sts rem.

Row 249: K2, yo, sl 3 tog kwise, k2tog, psso dec st, yo, k2—7 sts rem.

Row 250: Knit.

Row 251: K2, s2kp (see Glossary), k2—5 sts rem.

Row 252: Knit.

Row 253: K1, s2kp, k1—3 sts rem.

Row 254: Knit.

Row 255: Sk2p (see Glossary)—1 st rem.

Cut yarn and fasten off rem st.

Finishing

Weave in ends. Block to finished measurements.

Re-Blocking Knits to Regain Their Shape

Occasionally, a piece knit in a heavier yarn, such as a wrap, will lose its shape or stretch out with regular wear. You can easily re-block it by steaming or soaking, pinning it back to its original measurements, and letting it dry.

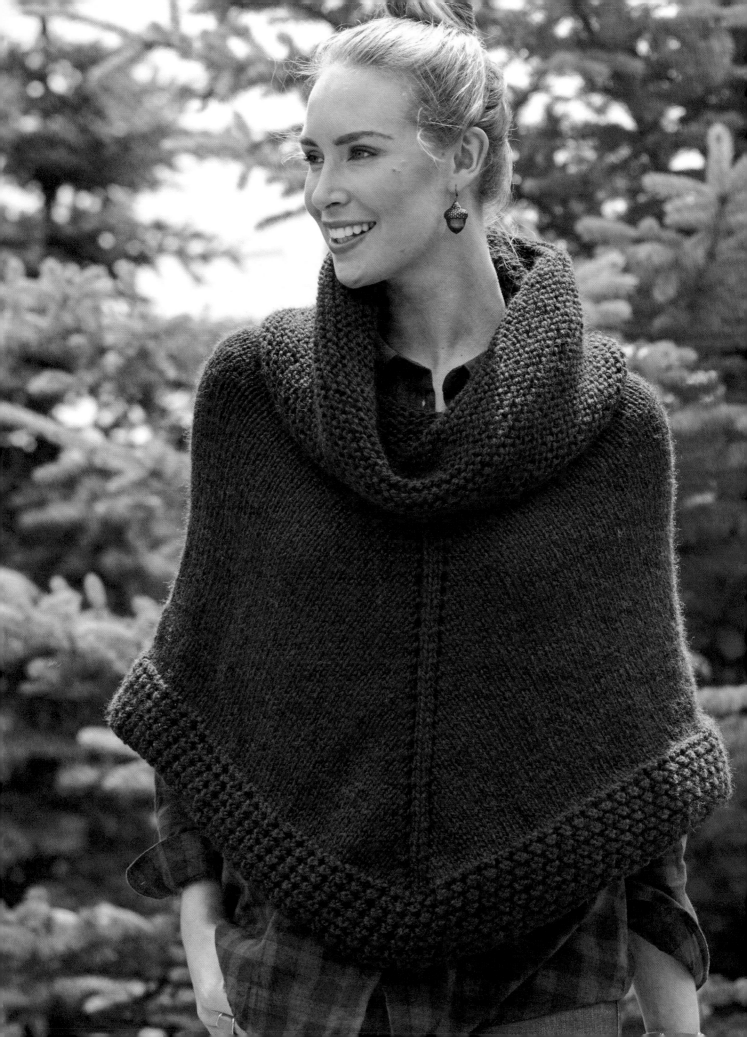

Not Quite a Sweater

Here are four great transitional-weather pieces. Shrugs don't have all of the coverage of a traditional cardigan, so they're a perfect piece to bring when the day's activities might go from a warm day to a cool night. A poncho with a cozy oversized cowl is an ideal layer for a crisp morning walk.

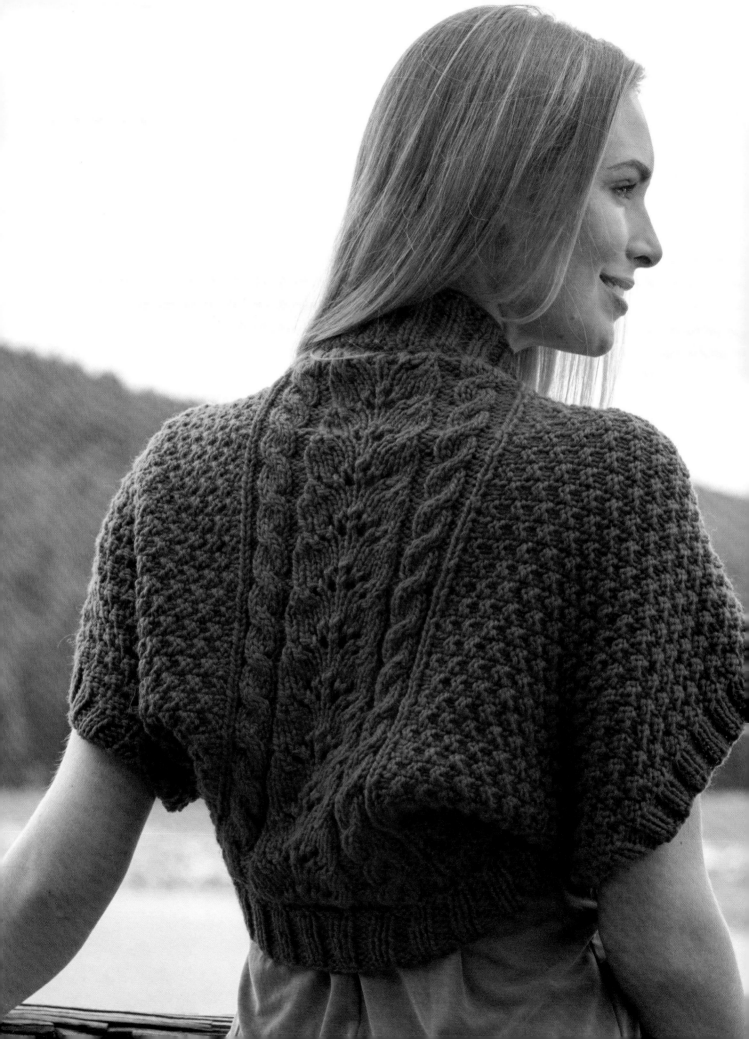

Designed by Cecily Glowik MacDonald

Wander Shrug

This cozy little shrug begins by working the center back cable and lace panel, then picking up stitches along the sides of the panel to continue the back and form the sleeves. Ribbed trims complete the piece. Worked in a soft bulky yarn in multiple simple texture stitches, this is not only a quick knit, but also a fun one.

Finished Size

To fit bust: 27–30 (31–34, 35–39, 40–44, 45–49, 50–54)" (68.5–76 [78.5–86.5, 89–99, 101.5–112, 114.5–124.5, 127–137] cm) circumference. Shown in size 31–34" (78.5–86.5 cm).

Yarn

Chunky weight (#5 Bulky).

Shown here: Cascade Eco+ (100% wool; 478 yd [437 m]/8.8 oz [250 g]): cinnamon, 1 (2, 2, 2, 2, 2) skein(s).

Needles

Size U.S. 9 (5.5 mm): 16" (40 cm) and 24" (60 cm) circular (cir). *Adjust needle size if necessary to obtain the correct gauge.*

Notions

Stitch markers (m); tapestry needle.

Gauges

15½ sts and 25 rows= 4" (10 cm) in Box Stitch.

29-st cable panel (not including edge sts) = 7" (18 cm) wide.

Stitch Guide

2/2RC (2 over 2 right cross): Sl 2 sts onto cn and hold in back of work, k2, k2 from cn.

2/2LC (2 over 2 left cross): Sl 2 sts onto cn and hold in front of work, k2, k2 from cn.

Cable Lace Panel (panel of 31 sts; also see chart on page 88)

Row 1 and all other WS rows: P2, k2, p4, k2, p11, k2, p4, k2, p2.

Rows 2 and 6: (RS) K2, p2, 2/2RC (see above), p2, k11, p2, 2/2LC (see above), p2, k2.

Row 4: K2, p2, k4, p2, [k2tog] twice, [yo, k1] 3 times, yo, [ssk] twice, p2, k4, p2, k2.

Row 8: K2, p2, k4, p2, k11, p2, k4, p2, k2.

Row 10: K2, p2, 2/2RC, p2, [k2tog] twice, [yo, k1] 3 times, yo, [ssk] twice, p2, 2/2LC, p2, k2.

Row 12: Rep Row 8.

Rep Rows 1–12 for Cable Lace Panel.

Box Stitch worked in rows (multiple of 4 sts; also see chart)

Rows 1 and 2: [P2, k2] to end.

Rows 3 and 4: [K2, p2] to end.

Rep Rows 1–4 for Box St worked in rows.

Box Stitch worked in the round (multiple of 4 sts; also see chart)

Rnds 1 and 2: [P2, k2] to end.

Rnds 3 and 4: [K2, p2] to end.

Rep Rnds 1–4 for Box st worked in the rnd.

Back

With shorter cir needle, CO 31 sts. Do not join.

Work Rows 1–12 of Cable Lace Panel (see Stitch Guide or chart) until piece measures 16½ (18½, 18½, 18½, 20½, 20½)" (42 [47, 47, 47, 52, 52] cm) from CO edge, ending with a WS row. BO all sts in patt.

Left Back

With longer cir and RS facing, pick up and knit 68 (76, 76, 76, 84, 84) sts evenly spaced along left edge of panel. Do not join.

Next row: (WS) Work Row 1 of Box St (see Stitch Guide or chart).

Cont in established patt until piece measures 4½ (5½, 7, 8½, 9¾, 11)" (11.5 [14, 18, 21.5, 25, 28] cm) from pick-up row, ending with a WS row.

Change to shorter cir needle.

Joining rnd: (RS) Work next row of established patt to end of row, do not turn. Place marker (pm) and join for working in rnds.

Cont with next rnd of established patt worked in rnds until piece measures 4" (10 cm) from joining rnd.

Next rnd: Purl.

Next rnd: [K2, p2] around.

Rep last rnd until rib measures 1½" (3.8 cm). BO all sts in patt.

Right Back

With longer cir needle and RS facing, pick up and knit 68 (76, 76, 76, 84, 84) sts evenly along right edge of panel. Do not join.

Work right back same as left.

Bottom Trim

Place removable m along bottom edge 3¼ (4¼, 5¾, 7¼, 8½, 9¾)" (8.5 [11, 14.5, 18.5, 21.5, 25] cm) out from either side of Cable Lace Panel.

With longer cir needle, pick up and knit 60 (68, 80, 88, 100, 108) sts between m, and remove m.

Next row: (WS) Knit.

Next row: (RS) P1, [k2, p2] to last 3 sts, k2, p1.

Next row: (WS) K1, [p2, k2] to last 3 sts, p2, k1.

Rep last 2 rows until rib measures 1½" (3.8 cm), ending with a WS row.

BO all sts loosely in patt.

Collar

Note: The stitches for the collar are picked up and knit, followed by a purl ridge row. The purl ridge row makes a good place to decrease or increase if you picked up the incorrect number of stitches.

With longer cir needle and RS facing, beg at right end of BO edge of bottom trim, pick up and knit 23 sts along side of bottom trim and rem bottom edge, 78 (94, 106, 118, 134, 146) sts evenly across top edge, then 23 sts along rem side of bottom edge and bottom trim—124 (140, 152, 164, 180, 192) sts. Do not join.

Next row: (WS) Knit.

Next row: (RS) K3, [p2, k2] to last 5 sts, p2, k3.

Next row: (WS) P3, [k2, p2] to last 5 sts, k2, p3.

Rep last 2 rows until rib measures 2" (5 cm), ending with a WS row.

BO all sts loosely in patt.

Finishing

Weave in all ends. Block to finished measurements.

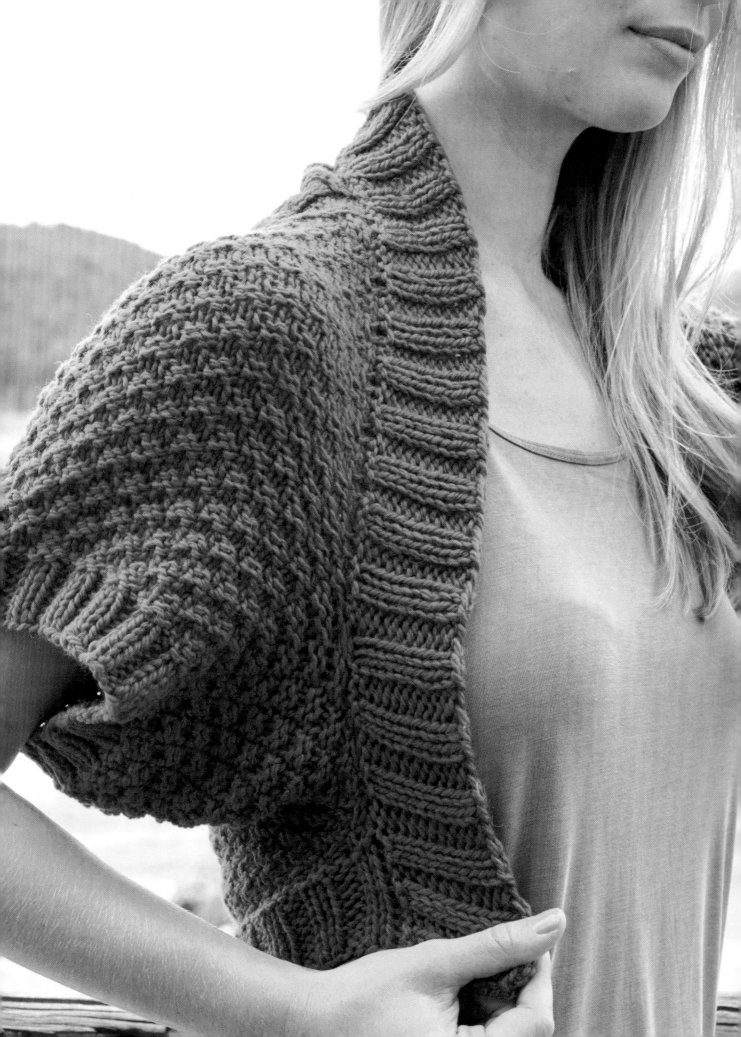

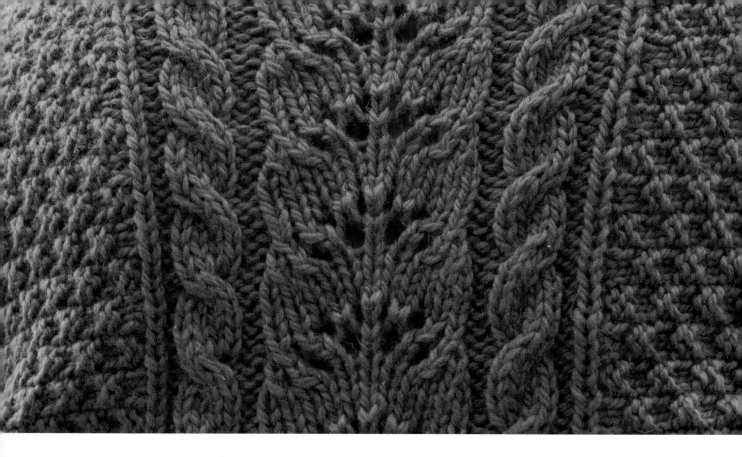

☐ k on RS, p on WS

• p on RS, k on WS

╱ k2tog

╲ ssk

o yo

◹◿ 2/2LC (see Stitch Guide)

◸◺ 2/2RC (see Stitch Guide)

▣ pattern repeat

Cable Lace Panel Chart

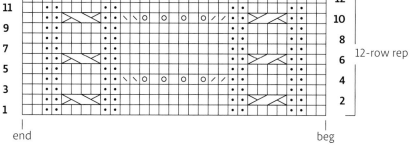

12-row rep

end beg

Box Stitch Chart

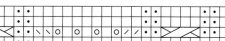

Note: When working Box St back and forth, read RS chart rows from right to left and WS chart rows from left to right; when working in the round, read all chart rows from right to left.

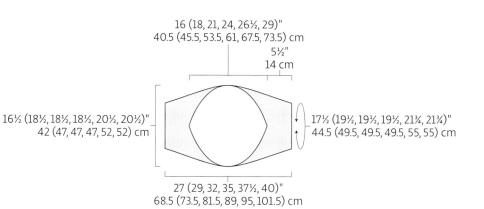

16 (18, 21, 24, 26½, 29)"
40.5 (45.5, 53.5, 61, 67.5, 73.5) cm

5½"
14 cm

16½ (18½, 18½, 18½, 20½, 20½)"
42 (47, 47, 47, 52, 52) cm

17½ (19½, 19½, 19½, 21¾, 21¾)"
44.5 (49.5, 49.5, 49.5, 55, 55) cm

27 (29, 32, 35, 37½, 40)"
68.5 (73.5, 81.5, 89, 95, 101.5) cm

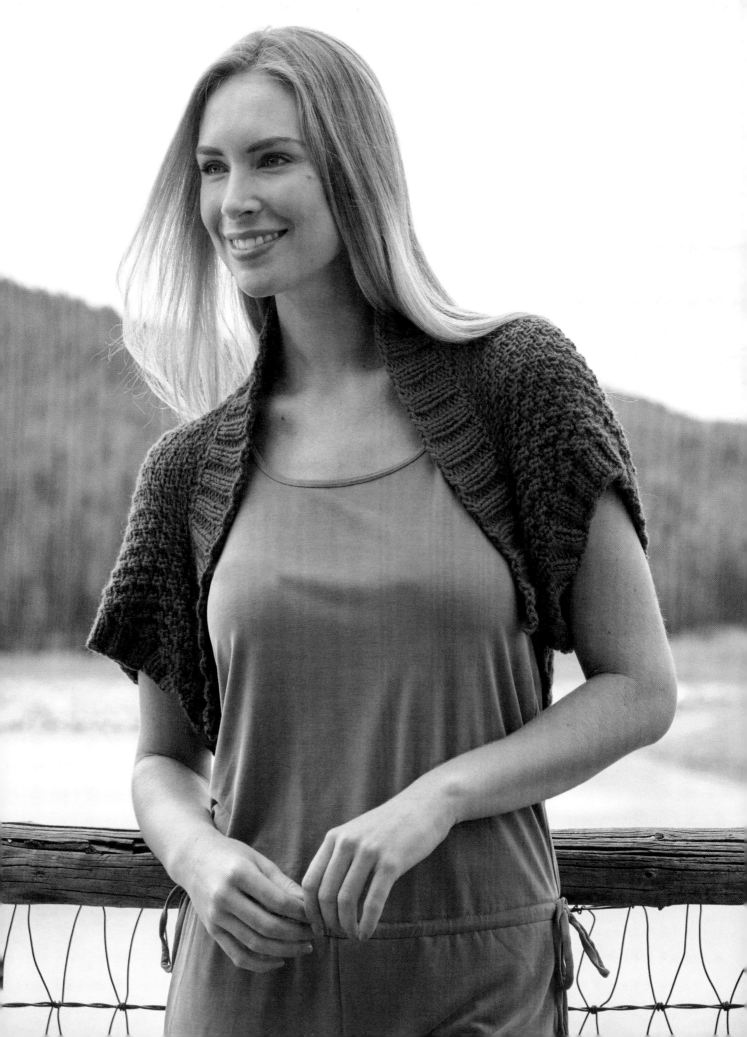

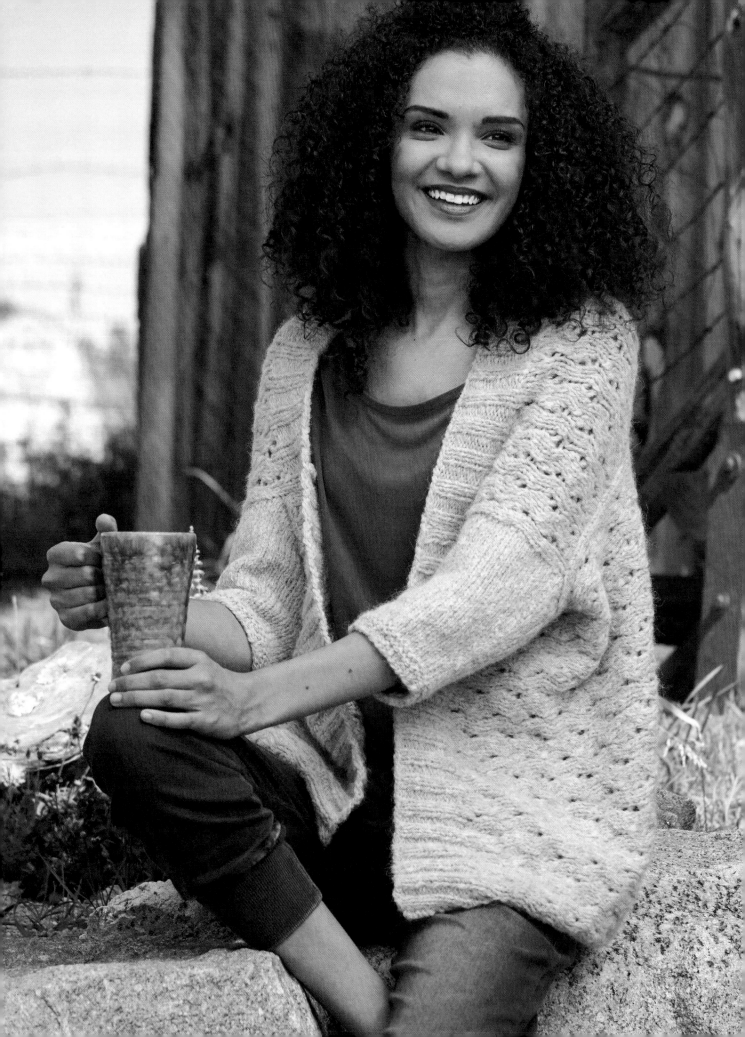

Designed by Amy Christoffers

North Star Cardigan

This design uses unique and easy-to-work shaping to form a beautiful, cozy cocoon-shaped cardigan. The deceptively simple lace pattern worked in two directions keeps the knitting interesting and makes for a beautiful finished piece.

Finished Size

28½" (72.5 cm) across back and 29½" (75 cm) long.

Yarn

Chunky weight (#5 Bulky).

Shown here: Berroco North Star (92% superfine alpaca, 8% nylon): 109 yd [100 m]/1¾ oz [50 g]): #3002 caribou, 9 balls.

Needles

Size U.S. 11 (8 mm): 36" (90 cm) circular (cir) and set of 4 or 5 double-pointed (dpn).

Size U.S. 10 (6 mm): 36" (90 cm) circular (cir) and set of 4 or 5 double-pointed (dpn).

Adjust needle sizes if necessary to obtain the correct gauge.

Gauges

13 sts and 17 rows = 4" (10 cm) in chart patt with larger needles.

15 sts and 22 rows = 4" (10 cm) in St st with larger needles.

Notes

The lower body is worked from side to side, placing markers for the armholes. Stitches for the back yoke are picked up between the markers, then worked up to the top edge. After joining the side seams, stitches for each sleeve are picked up along the armhole, then worked in stockinette from the armhole down.

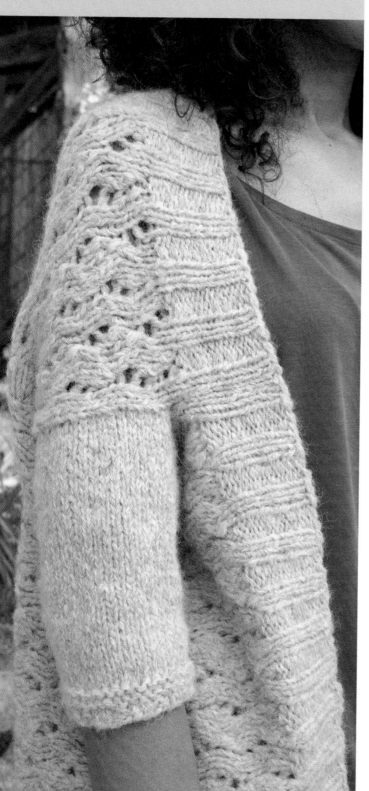

Lower Body

With smaller cir needle, CO 64 sts. Do not join.

Next row: (WS) P3, [k2, p2] to last st, p1.

Next row: (RS) K3, [p2, k2] to last st, k1.

Rep last 2 rows until rib measures 2¾" (7 cm) from beg, ending with a WS row.

Change to larger cir needle.

Work Lace Patt (see Stitch Guide or chart on page 94) Rows 1–8 four times, or until piece measures about 9¾" (25 cm) from beg, ending with Row 8.

Place marker (pm) at beg of next RS row.

Work Lace Patt Rows 1–8 sixteen times, or until piece measures about 28½" (72.5 cm) from m, ending with Row 8.

Pm at beg of next RS row.

Work Lace Patt Rows 1–8 four times, or until piece measures about 7" (18 cm) from second m, ending with Row 8.

Change to smaller cir needle.

Next row: (RS) K3, [p2, k2] to last st, k1.

Next row: (WS) P3, [k2, p2] to last st, p1.

Rep last 2 rows until rib measures 2¾" (7 cm), ending with a WS row. BO all sts loosely in patt.

Back Yoke

With larger cir needle and RS facing, rejoin yarn at first m. Pick up and knit 94 sts evenly along edge to second m (pick up sts at a rate of 3 sts for every 4 rows). Do not join.

Next row: (WS) Purl.

Work Lace Patt Rows 1–8 four times, or until piece measures about 7" (18 cm) from pick-up row, ending with Row 8 and inc 2 sts evenly spaced on last row—96 sts.

Change to smaller cir needle.

Next row: (RS) K3, [p2, k2] to last st, k1.

Next row: (WS) P3, [k2, p2] to last st, p1.

Rep last 2 rows until rib measures about 2¾" (7 cm), ending with a WS row.

Join Sides

Sew lower body and back yoke tog, beg at end of ribbing and sew tog about 3½" (9 cm) for side seam, leaving 6¼" (16 cm) open for armhole. Rep on other side of lower body and back yoke.

Picking Up Stitches Evenly

When a pattern requires the knitter to pick up a certain amount of stitches across an edge, sometimes the instruction will also include the direction "about xx sts for every xx rows" or "1 stitch for every stitch" to be used as a guideline. When it doesn't, you can use this trick to evenly pick them up: Divide the pick-up edge into a few equal sections, separated by locking stitch markers; then, using a calculator, divide the number of stitches to be picked up by the number of sections you've created. This will be the number of stitches that you'll need to pick up in each section to get the correct total number.

Lower Band

With smaller cir needle and RS facing, pick up and knit 170 sts along rem long edge of lower body (pick up sts at a rate of 3 sts for every 4 rows). Do not join.

BO all sts loosely kwise.

Sleeves

With larger dpn and RS facing, beg at side seam, pick up and knit 50 sts evenly spaced along sleeve opening. Pm for beg of rnd, join for working in rnds.

Work 5 rnds in St st (knit every rnd).

Dec rnd: K1, k2tog, knit to last 3 sts, ssk, k1—2 sts dec'd.

Rep dec rnd every 6 rnds 4 more times—40 sts rem.

Work 5 rnds even.

Change to smaller dpn.

[Knit 1 rnd, purl 1 rnd] twice, knit 1 rnd.

Next rnd: [K2, p2] to end.

BO all sts loosely in ribbing.

Finishing

Weave in loose ends. Block to finished measurements.

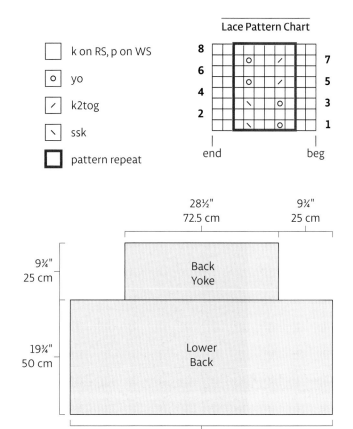

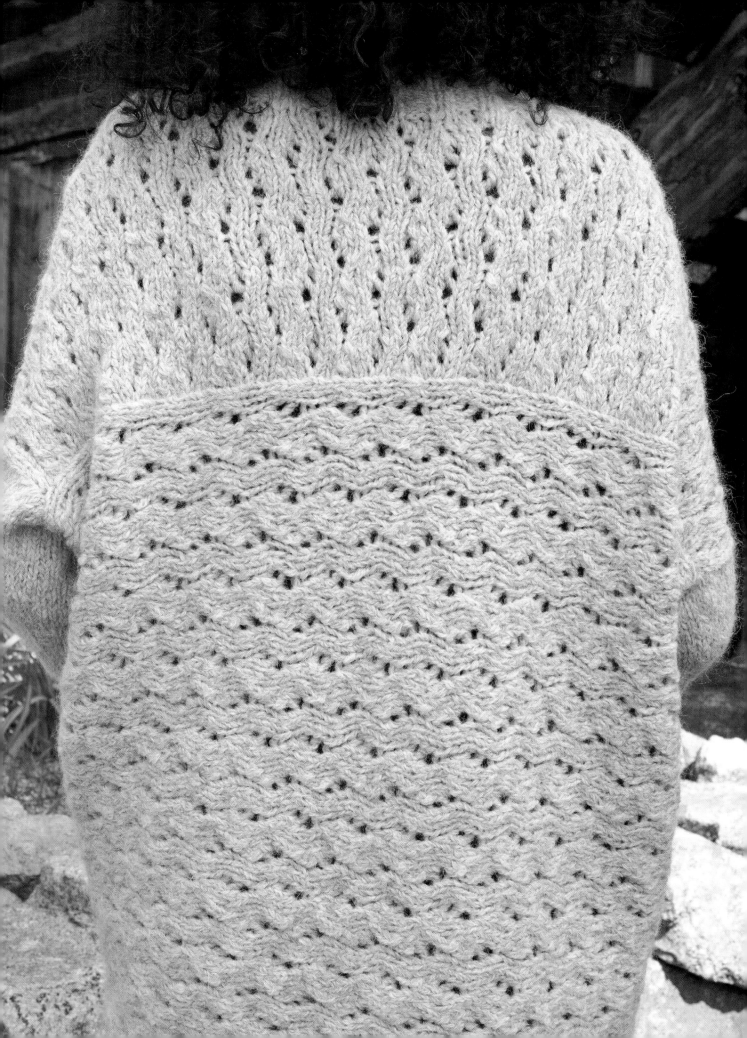

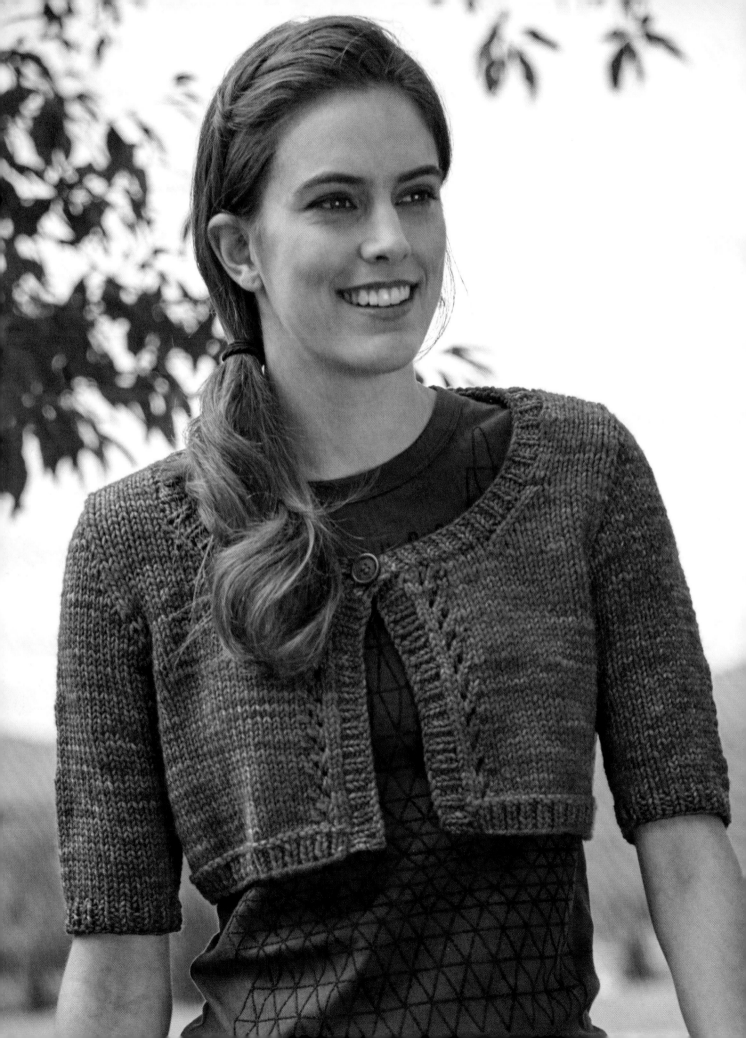

Designed by Cecily Glowik MacDonald

This is a great cover-up for cool summer nights or ocean breezes, when you need just a little extra layer. Knit from the bottom up with the simplest lace details, the body can easily be made longer if desired. With stitches picked up and short-row sleeve caps worked, the only seaming is at the shoulders.

Finished Size
33¼ (36½, 39¾, 43, 46, 49¼, 52½, 55¾, 59)" (84.5 [92.5, 101, 109, 117, 125, 133.5, 141.5, 150] cm) bust circumference with about 1" (2.5 cm) overlap, and 13½ (14, 14½, 14¾, 15¼, 15½, 16, 16½, 16¾)" (34.5 [35.5, 37, 37.5, 38.5, 39.5, 40.5, 42, 42.5] cm) long.
Shown in size 36½" (92.5 cm).

Yarn
Aran weight (#4 Medium).
Shown here: Malabrigo Twist (100% baby merino; 150 yd [137 m]/3½ oz [100 g]): #TW098 tuareg, 3 (4, 4, 4, 4, 5, 5, 5, 5) skeins.

Needles
Size U.S. 10 (6 mm): 29" (74 cm) circular (cir) and set of 5 double-pointed (dpn). *Adjust needle size if necessary to obtain the correct gauge.*

Notions
Stitch markers (m); stitch holders or waste yarn; tapestry needle; one ⅞" (22 mm) button.

Gauge
15 sts and 23 rows = 4" (10 cm) in St st.

Note
A circular needle is used for the body to accommodate the large number of stitches; do not join, but work back and forth.

Right Lace Panel (panel of 3 sts)

Row 1: (RS) Yo, ssk, k1.

Rows 2 and 4: (WS) Purl.

Row 3: K1, yo, ssk.

Rep Rows 1–4 for Right Lace Panel.

Left Lace Panel (panel of 3 sts)

Row 1: (RS) K1, k2tog, yo.

Rows 2 and 4: Purl.

Row 3: K2tog, yo, k1.

Rep Rows 1–4 for Left Lace Panel.

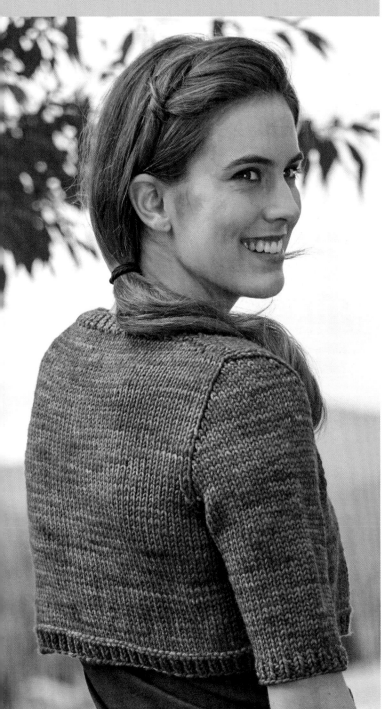

Body

With cir needle, CO 123 (135, 147, 159, 171, 183, 195, 207, 219) sts. Do not join.

Next row: (WS) *P1, k1; rep from * to last st, p1.

Next row: (RS) *K1, p1; rep from * to last st, k1.

Rep last 2 more rows once more.

Next row: (WS) Knit.

Set-up row: (RS) Work 2 sts in St st (knit on RS, purl on WS), place marker (pm), work Row 1 of Right Lace Panel (see Stitch Guide or chart on page 100) over next 3 sts, pm, work in St st to last 5 sts, pm, work Row 1 of Left Lace Panel (see Stitch Guide or chart on page 100) over next 3 sts, pm, work in St st to end.

Next row: (WS) Purl to m, sl m, work Row 2 of Left Lace Panel over next 3 sts, sl m, purl to next m, sl m, work Row 2 of Right Lace Panel over next 3 sts, sl m, purl to end.

Cont in established patt until piece measures 6" (15 cm) from CO edge, ending with a WS row.

Shape armholes

Next row: (RS) Work 26 (29, 32, 34, 37, 40, 42, 45, 48) sts and place onto holder or waste yarn for Right Front, BO next 8 (8, 8, 10, 10, 10, 12, 12, 12) sts for armhole, work 55 (61, 67, 71, 77, 83, 87, 93, 99) sts and place onto holder for Back, BO next 8 (8, 10, 10, 10, 12, 12, 12) sts for armhole, work rem 26 (29, 32, 34, 37, 40, 42, 45, 48) sts for Left Front.

Left Front

Work 1 row even in established patt.

Armhole dec row: (RS) K1, ssk, work to end—1 st dec'd at armhole.

Rep armhole dec row every RS row 4 (5, 7, 9, 10, 11, 13, 15, 17) more times. *At the same time,* when armhole measures 1½ (2, 2½, 2¾, 3¼, 3½, 4, 4½, 4¾)" (3.8 [5, 6.5, 7, 8.5, 9, 10, 11.5, 12] cm), end with a RS row.

Shape neck

Next row: (WS) BO 9 sts, work to end.

Neck dec row: (RS) Work to last 3 sts, k2tog, k1—1 st dec'd at neck edge.

Rep neck dec row every RS row 4 more times—7 (9, 10, 10, 12, 14, 14, 15, 16) sts rem when all shaping is complete.

Cont even until armhole measures 7 (7½, 8, 8¼, 8¾, 9, 9½, 10, 10¼)" (18 [19, 20.5, 21, 22, 23, 24, 25.5, 26] cm), ending with a WS row.

Shape shoulder

BO at beg of RS rows 3 (4, 5, 5, 6, 7, 7, 7, 8) sts once, then 4 (5, 5, 5, 6, 7, 7, 8, 8) sts once.

Right Front

Return held 26 (29, 32, 34, 37, 40, 42, 45, 48) sts for Right Front to cir needle. Join yarn to beg with a WS row.

Work 1 WS row even.

Shape armhole

Armhole dec row: (RS) Work to last 3 sts, k2tog, k1—1 st dec'd at armhole.

Rep armhole dec row every RS row 4 (5, 7, 9, 10, 11, 13, 15, 17) more times. *At the same time*, when armhole measures 1½ (2, 2½, 2¾, 3¼, 3½, 4, 4½, 4¾)" (3.8 [5, 6.5, 7, 8.5, 9, 10, 11.5, 12] cm), end with a WS row.

Shape neck

Next row: (RS) BO 9 sts, work to end.

Work 1 row even.

Neck dec row: (RS) K1, ssk, work to end—1 st dec'd at neck.

Rep neck dec row every RS row 4 more times—7 (9, 10, 10, 12, 14, 14, 15, 16) sts rem when all shaping is complete.

Cont even until piece measures 7 (7½, 8, 8¼, 8¾, 9, 9½, 10, 10¼)" (18 [19, 20.5, 21, 22, 23, 24, 25.5, 26] cm), ending with a RS row.

Shape shoulder

BO at beg of WS rows 3 (4, 5, 5, 6, 7, 7, 7, 8) sts once, then 4 (5, 5, 5, 6, 7, 7, 8, 8) sts once.

Back

Return held 55 (61, 67, 71, 77, 83, 87, 93, 99) sts for back to cir needle. Join yarn to beg with a WS row.

Work 1 WS row even.

Armhole dec row: (RS) K1, ssk, work in St st to last 3 sts, k2tog, k1—2 sts dec'd.

Rep armhole dec row every RS row 3 (4, 5, 7, 8, 9, 10, 11, 13) more times—47 (51, 55, 55, 59, 63, 65, 69, 71) sts rem.

Work even until armhole measures 7 (7½, 8, 8¼, 8¾, 9, 9½, 10, 10¼)" (18 [19, 20.5, 21, 22, 23, 24, 25.5, 26] cm), ending with a WS row.

Shape shoulders

BO 3 (4, 5, 5, 6, 7, 7, 7, 8) sts at beg of next 2 rows, then 4 (5, 5, 5, 6, 7, 7, 8, 8) sts at beg of next 2 rows—33 (33, 35, 35, 35, 35, 37, 39, 39) sts rem.

BO rem sts.

Sew shoulder seams.

Sleeves

With dpn and RS facing, pick up and knit 8 (8, 8, 10, 10, 10, 12, 12, 12) sts in BO underarm sts, 21 (23, 24, 25, 26, 27, 28, 29, 30) sts along armhole to shoulder seam (about 1 st for every 2 rows), pm, 21 (23, 24, 25, 26, 27, 28, 29, 30) sts along armhole edge—50 (54, 56, 60, 62, 64, 68, 70, 72) sts.

Sleeve cap short-rows (see Glossary)

Short-row 1: (WS) Work in St st to 4 (5, 5, 5, 6, 6, 6, 7, 7) sts past m, wrap and turn.

Short-row 2: (RS) Work in St st to 4 (5, 5, 5, 6, 6, 6, 7, 7) sts past m, wrap and turn.

Short-row 3: Work to wrapped st, hide wrap, wrap and turn.

Rep last short-row 33 (33, 35, 39, 37, 39, 43, 41, 43) more times—8 (10, 10, 10, 12, 12, 12, 14, 14) sts rem unworked. Do not turn after last short-row.

Knit 4 (5, 5, 5, 6, 6, 6, 7, 7) sts, pm for beg of rnd, and join for working in rnds.

Work even in St st (knit every rnd) for 1" (2.5 cm) and remove m at shoulder seam on first rnd.

Dec rnd: K1, k2tog, knit to last 3 sts, ssk, k1—2 sts dec'd.

Rep dec rnd every 6 rnds 4 more times—40 (44, 46, 50, 52, 54, 58, 60, 62) sts rem.

Cont even until sleeve measures 6" (15 cm) from underarm.

Next rnd: Purl.

Next rnd: *K1, p1; rep from * around.

Rep last rnd until rib measures ½" (1.3 cm).

BO all sts in rib.

Left Front Band

With cir needle and RS facing, beg at neck edge, pick up and knit 29 (31, 33, 35, 37, 37, 39, 42, 43) sts along left front edge (about 3 sts for every 4 rows).

Next row: (WS) *P1, k1; rep from * to last st, p1.

Next row: (RS) *K1, p1; rep from * to last st, k1.

Rep last 2 rows once more.

BO all sts loosely in rib.

Right Front Band

With cir needle and RS facing, and beg at bottom edge, pick up and knit 29 (31, 33, 35, 37, 37, 39, 42, 43) sts along right front edge (about 3 sts for every 4 rows).

Next row: (WS) *P1, k1; rep from * to last st, p1.

Next row: (RS) *K1, p1; rep from * to last st, k1.

Rep last 2 rows once more.

BO all sts loosely in rib.

Neckband

With cir needle and RS facing, pick up and knit 34 sts along right front band and neck edge to shoulder, 33 (33, 35, 35, 35, 35, 37, 39, 39) sts along back neck edge, then 34 sts along left front neck and front band—101 (101, 103, 103, 103, 103, 105, 107, 107) sts.

Next row: (WS) *P1, k1; rep from * to last st, p1.

Next (buttonhole) row: (RS) K1, p1, k2tog, yo, [k1, p1] to last st, k1.

Next row: *P1, k1; rep from * to last st, p1.

Next row: *K1, p1; rep from * to last st, k1.

BO all sts loosely in rib.

Finishing

Weave in all ends. Block to finished measurements.

Sew button to left neckband opposite buttonhole.

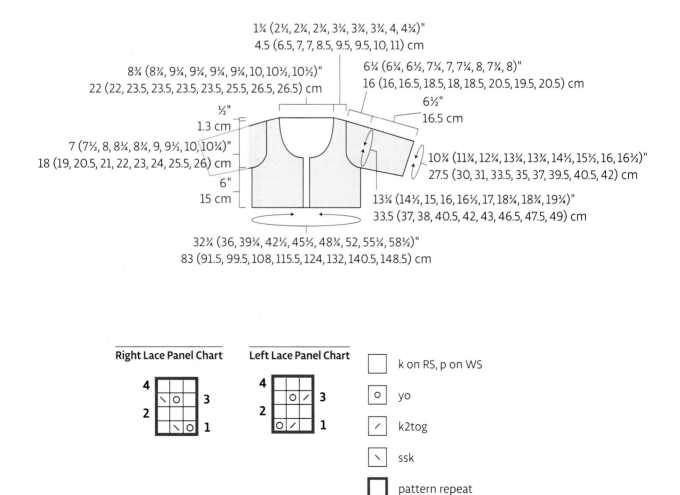

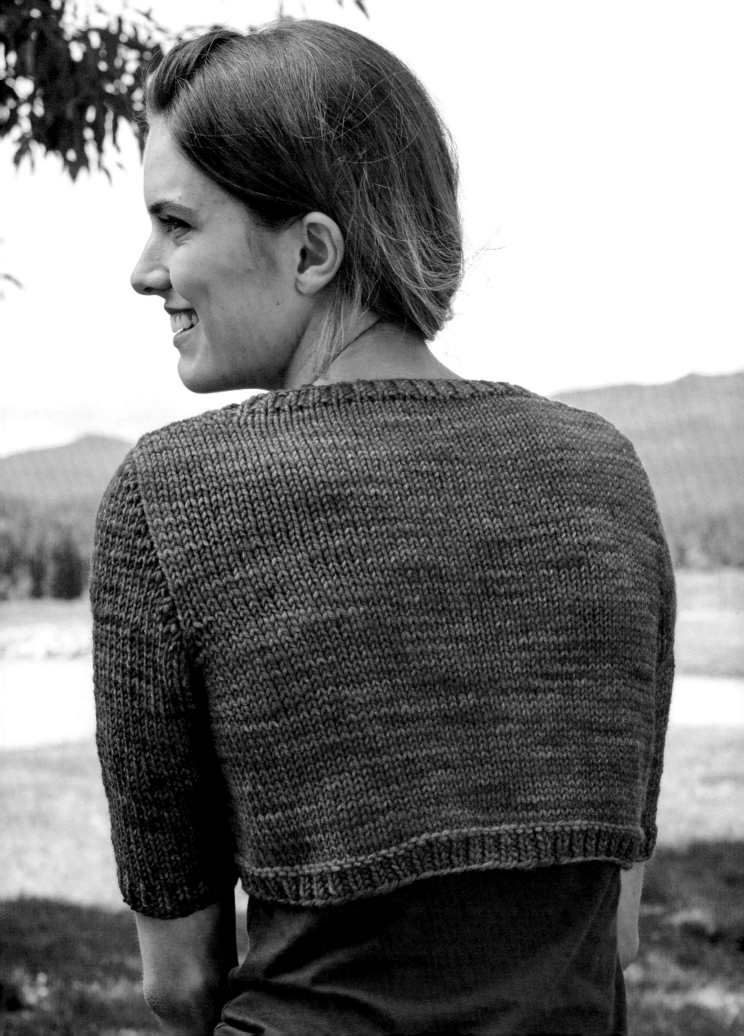

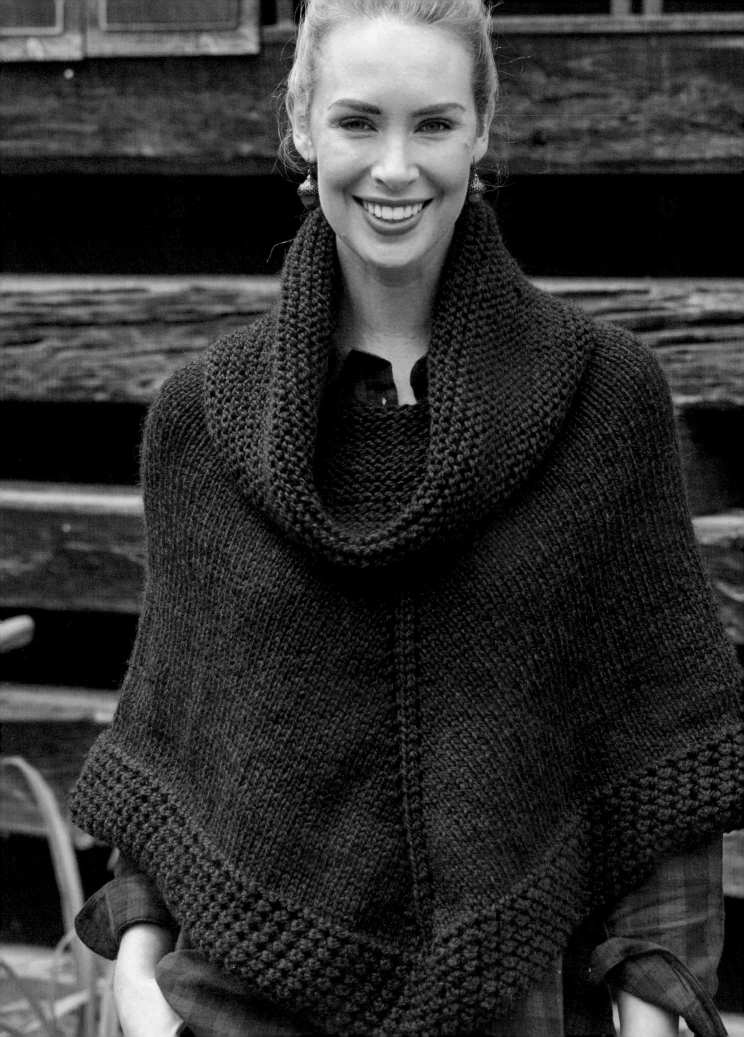

Designed by Melissa LaBarre

Getaway Poncho

This sumptuous poncho is a great cover-up on a crisp fall weekend away.
Knit from the top down in a bulky yarn with a big garter-stitch cowl and
a stockinette-stitch body, it's easy enough to be a relaxing and quick knit.
The addition of a simple eyelet pattern at the bottom keeps it interesting.

Finished Size

Top of cowl circumference: 32" (81.5 cm).

Neck circumference: 26" (66 cm).

Bottom body circumference: 64" (162.5 cm).

Length, from cowl along center front: 23"
(58.5 cm).

Yarn

Bulky weight (#6 Super Bulky).

Shown here: Berocco Peruvia Quick (100% wool;
103 yd [94 m]/3½ oz [100 g]): #9152 saddle brown,
8 skeins.

Needles

Size U.S. 10½ (6.5 mm): 24" (60 cm) and 32" (80
cm) circular (cir). *Adjust needle size if necessary to
obtain the correct gauge.*

Notions

Stitch markers (m); tapestry needle.

Gauges

12 sts and 17 rnds = 4" (10 cm) in St st.

12 sts and 22 rnds = 4" (10 cm) in garter st.

Notes

Poncho begins at cowl neck and is worked in
garter stitch with two decrease rounds to the
neck. The body is then worked in stockinette
stitch, shaped with yarnover increases along the
center front and back and finished with a garter
eyelet trim.

Stitch Guide

Garter Stitch worked in the round (any number of sts)

Rnd 1: Purl.

Rnd 2: Knit.

Rep Rnds 1 and 2 for garter st worked in the rnd.

Stockinette Stitch worked in the round (any number of sts)

Knit every rnd.

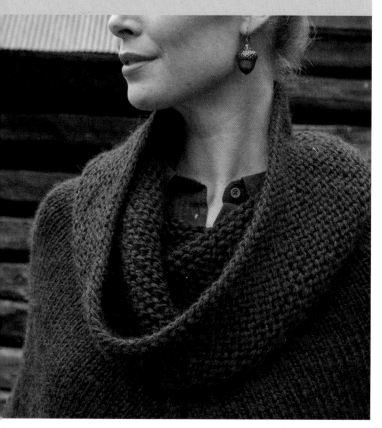

Cowl Neck

With shorter cir needle, CO 98 sts. Place marker (pm) for beg of rnd, and join for working in rnds, being careful not to twist sts.

Work in garter st until piece measures 8" (20.5 cm) from CO edge, ending with a purl rnd.

Dec rnd: K3, k2tog, *k8, k2tog; rep from * to last 3 sts, k3—88 sts rem.

Cont even until piece measures 10" (25.5 cm) from CO edge, ending with a purl rnd.

Dec rnd: K2, k2tog, *k7, k2tog; rep from * to last 3 sts, k3—78 sts rem.

Cont even until piece measures 12" (30.5 cm) from CO edge, ending with a purl rnd.

Body

Set-up rnd: K39, pm for center front, knit to end.

Body Shaping

Change to longer cir needle when there are too many sts to work comfortably on shorter cir needle.

Inc rnd: K1, yo, knit to 1 st before m, yo, k1, sl m, k1, yo, work to last st, yo, k1—4 sts inc'd.

Next rnd: Knit.

Rep last 2 rnds 33 more times, then rep inc rnd once more—218 sts. Piece should measure about 20" (51 cm) from cowl along center front.

Bottom Trim

Rnd 1: Purl.

Rnd 2: *Yo, k2tog; rep from * around.

Rep last 2 rnds 6 more times.

BO all sts pwise.

Finishing

Weave in all ends. Block piece to finished measurements.

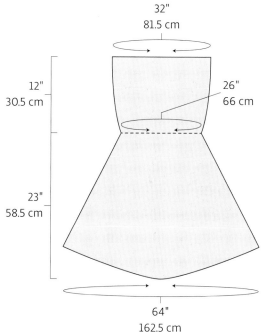

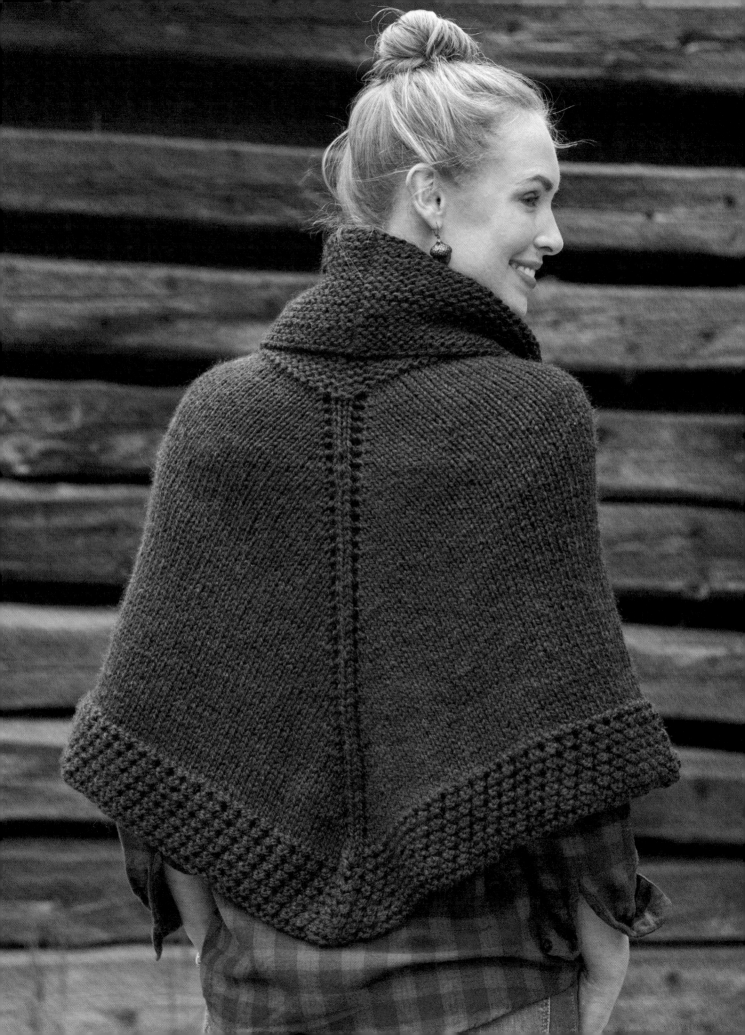

Abbreviations

beg begin(s), beginning

BO bind off

cir circular

cm centimeter

cn cable needle

CO cast on

cont continue(s), continuing

dec('d) decrease(d), decreasing

dpn double-pointed needle(s)

foll follow(s), following

g gram(s)

inc('d) increase(d), increasing

k knit

k1f/b/f knit into the front, back, then front of the same stitch (see Glossary)

k1f&b knit into the front and back of the same stitch (see Glossary)

k2tog knit 2 together (see Glossary)

k3tog knit 3 together (see Glossary)

kwise knitwise, as if to knit

LH left hand

m marker(s)

mm millimeter(s)

M1 make one (increase)

oz ounce(s)

p purl

p2tog purl 2 together (see Glossary)

patt(s) pattern(s)

pm place marker

psso pass slipped stitch over

pwise purlwise, as if to purl

rem remain(s), remaining

rep repeat(s), repeating

rev St st reverse stockinette stitch

RH right hand

rnd(s) round(s)

RS right side

s2kp slip 2, knit 1, psso (see Glossary)

sk2p slip 1, k2tog, psso (see Glossary)

skp slip 1 stitch knitwise, knit 1, pass slipped stitch over (decrease)

sl slip

ssk slip, slip, knit (see Glossary)

ssp slip, slip, purl (see Glossary)

sssk slip, slip, slip, knit (see Glossary)

st(s) stitch(es)

St st stockinette stitch

tbl through the back loop

tog together

WS wrong side

wyb with yarn in back

wyf with yarn in front

yd yard(s)

yo yarnover (see Glossary)

* repeat starting point

** repeat all instructions between asterisks

() alternate measurements and/or instructions

[] work instructions as a group a specified number of times

Glossary

Bind-Offs

Channel Island Bind-Off

Step 1. Insert tip of right needle through the first stitch on left needle, leaving this stitch on left needle, then pull the second stitch on left needle through the first **(Figure 1)** and place it on tip of left needle—2 stitches are crossed on the needle.

Step 2. Knit the first of the crossed stitches and leave the second stitch on the needle **(Figure 2)**.

Step 3. Slip the new stitch onto left needle **(Figure 3)**, and knit it again, then knit the next 2 stitches together **(Figure 4)**.

Step 4. Slip the second stitch on right needle over the first stitch **(Figure 5)** and off the needle to bind off 1 stitch.

Step 5. Return the remaining stitch to left needle.

Repeat these 5 steps to end.

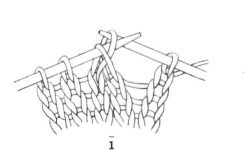

1

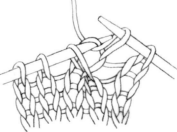

2

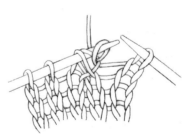

3

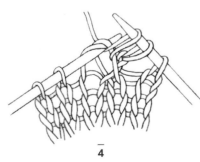

4

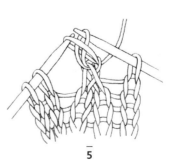

5

Standard Bind-Off

Knit the first stitch, *knit the next stitch (2 stitches on right needle), insert left needle tip into the first stitch on right needle **(Figure 1)** and lift this stitch up and over the second stitch **(Figure 2)** and off the needle **(Figure 3)**. Repeat from * for the desired number of stitches.

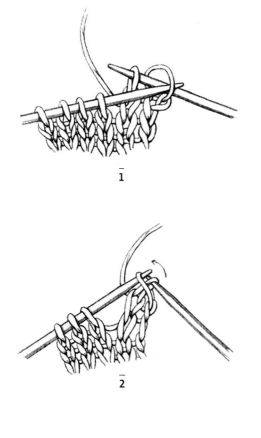

1

2

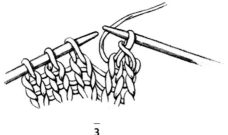

3

Three-Needle Bind-Off

Place the stitches to be joined onto two separate needles and hold the needles parallel so that the right sides of knitting face together. Insert a third needle into the first stitch on each of the two needles **(Figure 1)** and knit them together as 1 stitch **(Figure 2)**, *knit the next stitch on each needle the same way, then use the left needle tip to lift the first stitch over the second and off the needle **(Figure 3)**. Repeat from * until no stitches remain on first two needles. Cut yarn and pull tail through last stitch to secure.

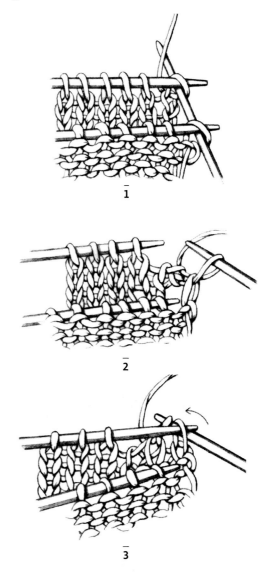

1

2

3

Brioche Knitting

Slip 1, Yarnover (sl1yo)

Bring yarn to front, slip 1 st purlwise, bring yarn over top of needle to back.

Brioche Knit 1 (brk1)

Knit the stitch that was slipped in the previous row together with its yarnover.

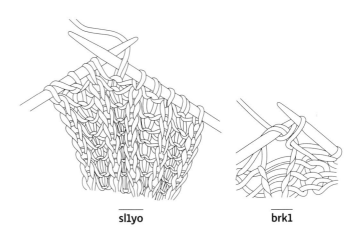

sl1yo brk1

Cables

Slip the designated number of stitches (usually 2 or 3) onto a cable needle, hold the cable needle in front of the work for a left-leaning twist **(Figure 1)** or in back of the work for a right-leaning twist **(Figure 2)**, work the specified number of stitches from the left needle (usually the same number of stitches that were placed on the cable needle), then work the stitches from the cable needle in the order in which they were placed on the needle **(Figure 3)**.

1

2

3

Cast-Ons

Cable Cast-On

If there are no stitches on the needles, make a slipknot of working yarn and place it on the needle, then use the knitted method (see page 110) to cast on 1 more stitch—2 stitches on needle. Hold needle with working yarn in your left hand. *Insert right needle between the first 2 stitches on left needle **(Figure 1)**, wrap yarn around needle as if to knit, draw yarn through **(Figure 2)**, and place new loop on left needle **(Figure 3)** to form a new stitch. Repeat from * for the desired number of stitches, always working between the 2 stitches closest to the tip of the left needle.

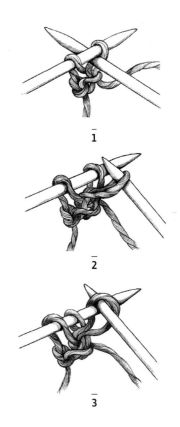

1

2

3

Crochet Provisional Cast-On

Place a slipknot on a crochet hook. Hold the needle and yarn in your left hand with the yarn under the needle. Place hook over needle, wrap yarn around hook, and pull the loop through the slipknot **(Figure 1)**. *Bring yarn to back under needle tip, wrap yarn around hook, and pull it through loop on hook **(Figure 2)**. Repeat from * until there is one less than the desired number of stitches. Bring the yarn to the back and slip the remaining loop from the hook onto the needle.

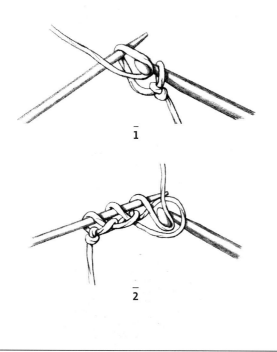

Knitted Cast-On

If there are no stitches on the needles, make a slipknot of working yarn and place it on the left needle. When there is at least 1 stitch on the left needle, *use the right needle to knit the first stitch (or slipknot) on left needle **(Figure 1)** and place new loop onto left needle to form a new stitch **(Figure 2)**. Repeat from * for the desired number of stitches, always working into the last stitch made.

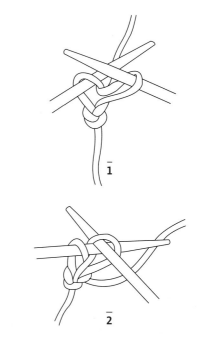

Long-Tail (Continental) Cast-On

Leaving a long tail (about ½" [1.3 cm] for each stitch to be cast on), make a slipknot and place on right needle. Place thumb and index finger of your left hand between the yarn ends so that working yarn is around your index finger and tail end is around your thumb and secure the yarn ends with your other fingers. Hold your palm upward, making a V of yarn **(Figure 1)**. *Bring needle up through loop on thumb **(Figure 2)**, catch first strand around index finger, and go back down through loop on thumb **(Figure 3)**. Drop loop off thumb and, placing thumb back in V configuration, tighten resulting stitch on needle **(Figure 4)**. Repeat from * for desired number of stitches.

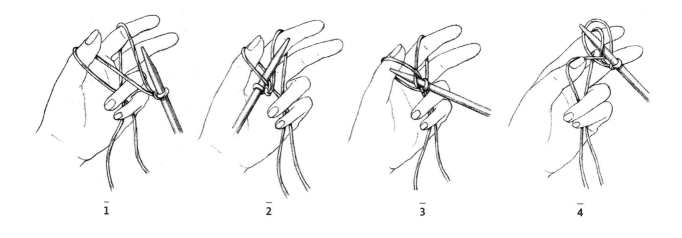

Provisional Cast-On

Place a loose slipknot on the needle held in your right hand. Hold the waste yarn next to the slipknot and around the left thumb; hold working yarn over left index finger. *Bring the right needle forward under waste yarn, over working yarn, grab a loop of working yarn **(Figure 1)**, then bring the needle to the front, over both yarns, and grab a second loop **(Figure 2)**. Repeat from * for desired number of stitches.

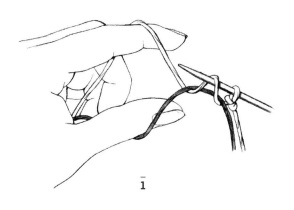

1

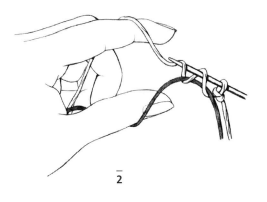

2

Decreases

Centered Double Decrease (s2kp)

Slip 2 stitches together knitwise **(Figure 1)**, knit the next stitch **(Figure 2)**, then pass the slipped stitches over the knitted stitch **(Figure 3)**.

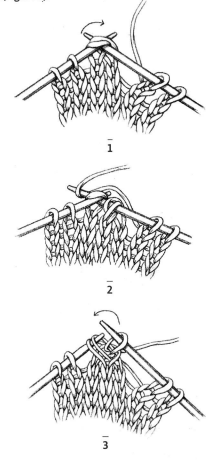

1

2

3

Knit 2 Together (k2tog)

Knit 2 stitches together as if they were a single stitch.

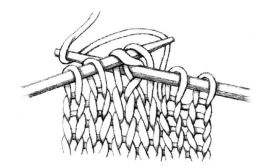

Knit 3 Together (k3tog)

Knit 3 stitches together as if they were a single stitch.

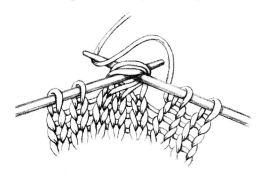

Purl 2 Together (p2tog)

Purl 2 stitches together as if they were a single stitch.

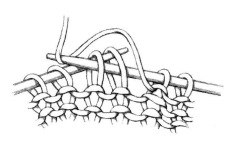

Left-Slant Double Decrease (sk2p)

Slip 1 stitch knitwise to right needle, knit the next 2 stitches together **(Figure 1)**, then use the tip of the left needle to lift the slipped stitch up and over the knitted stitches **(Figure 2)**, then off the needle.

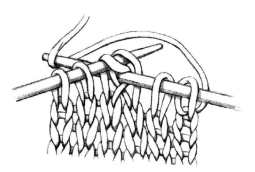

1

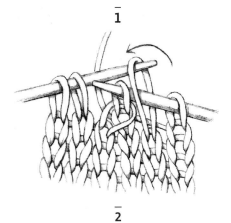

2

Slip, Slip, Knit (ssk)

Slip 2 stitches individually knitwise **(Figure 1)**, insert left needle tip into the front of these 2 slipped stitches, and use right needle to knit them together through their back loops **(Figure 2)**.

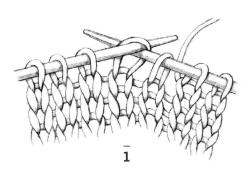

1

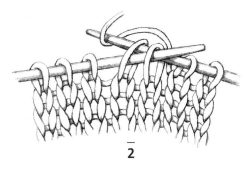

2

Slip, Slip, Purl (ssp)

Holding yarn in front, slip 2 stitches individually knitwise **(Figure 1)**, then slip these 2 stitches back onto left needle (they will be turned on the needle) and purl them together through their back loops **(Figure 2)**.

Slip, Slip, Slip, Knit (sssk)

Slip 3 stitches individually knitwise **(Figure 1)**, insert left needle tip into the front of these 3 slipped stitches, and use the right needle to knit them together through their back loops **(Figure 2)**.

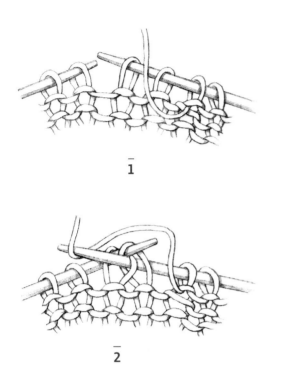

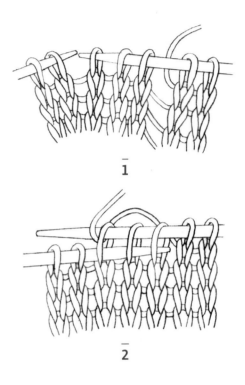

Gauge: How to Measure

Knit a swatch at least 4" (10 cm) square. Remove the stitches from the needles or bind them off loosely and lay the swatch on a flat surface. Place a ruler over the swatch and count the number of stitches across and number of rows down (including fractions of stitches and rows) in 2" (5 cm) and divide this number by two to get the number of stitches (including fractions of stitches) in one inch. Repeat two or three times on different areas of the swatch to confirm the measurements. If you have more stitches and rows than called for in the instructions, knit another swatch with larger needles; if you have fewer stitches and rows, knit another swatch with smaller needles.

Grafting

Kitchener Stitch

Arrange stitches on two needles so that there is the same number of stitches on each needle. Hold the needles parallel to each other with wrong sides of the knitting together. Allowing about ½" (1.3 cm) per stitch to be grafted, thread matching yarn onto a tapestry needle. Work from right to left as follows:

Step 1. Bring tapestry needle through the first stitch on the front needle as if to purl and leave the stitch on the needle **(Figure 1)**.

Step 2. Bring tapestry needle through the first stitch on the back needle as if to knit and leave that stitch on the needle **(Figure 2)**.

Step 3. Bring tapestry needle through the first front stitch as if to knit and slip this stitch off the needle, then bring tapestry needle through the next front stitch as if to purl and leave this stitch on the needle **(Figure 3)**.

Step 4. Bring tapestry needle through the first back stitch as if to purl and slip this stitch off the needle, then bring tapestry needle through the next back stitch as if to knit and leave this stitch on the needle **(Figure 4)**.

Repeat Steps 3 and 4 until 1 stitch remains on each needle, adjusting the tension to match the rest of the knitting as you go. To finish, bring tapestry needle through the front stitch as if to knit and slip this stitch off the needle, then bring tapestry needle through the back stitch as if to purl and slip this stitch off the needle.

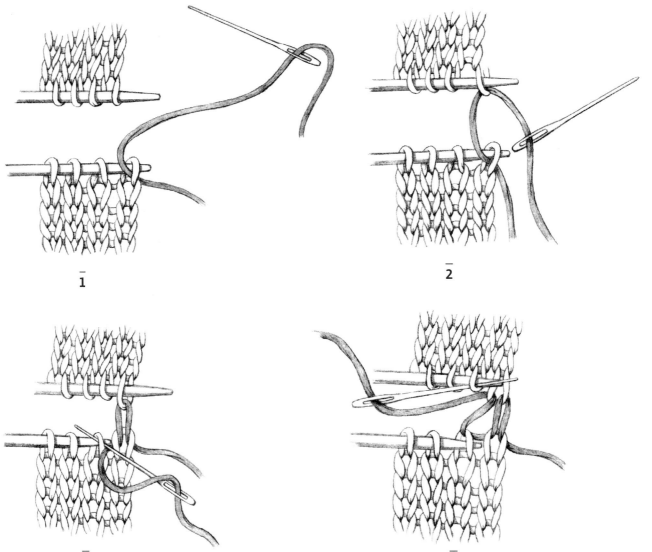

1

2

3

4

Increases

Double Increase—Knit 1 Through Front, then Back, then Front Again (k1f/b/f)

Knit into a stitch but leave it on the left needle **(Figure 1)**, then knit through the back loop of the same stitch **(Figure 2)** and leave it on the left needle, then knit through the front loop of the same stitch again **(Figure 3)** and slip the original stitch off the left needle **(Figure 4)**.

Knit 1 Through Front and Back (k1f&b)

Knit into a stitch but leave it on the left needle **(Figure 1)**, then knit through the back loop of the same stitch **(Figure 2)** and slip the original stitch off the needle **(Figure 3)**.

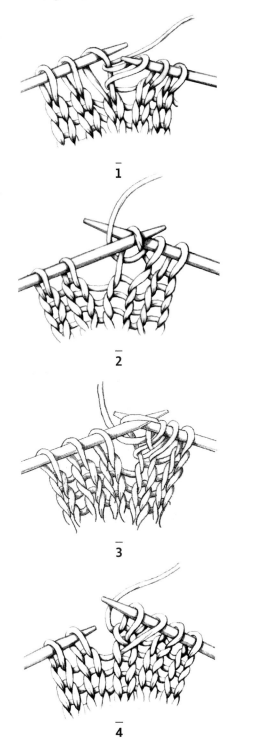

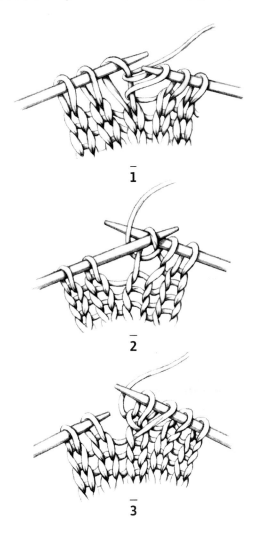

Raised Make One—Left Slant (M1L)

Note: Use the left slant if no direction of slant is specified.

With left needle tip, lift the strand between the last knitted stitch and the first stitch on the left needle from front to back **(Figure 1)**, then knit the lifted loop through the back **(Figure 2)**.

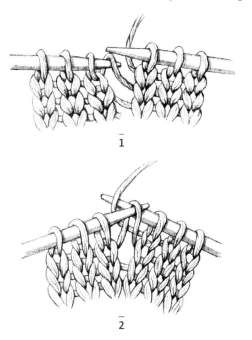

1

2

Raised Make One—Right Slant (M1R)

With left needle tip, lift the strand between the needles from back to front **(Figure 1)**. Knit the lifted loop through the front **(Figure 2)**.

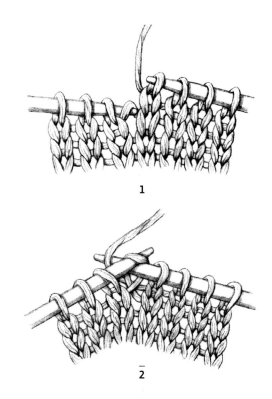

1

2

Raised Make One Purlwise (M1P)

With left needle tip, lift the strand between the needles from front to back **(Figure 1)**, then purl the lifted loop through the front **(Figure 2)**.

1

2

Knit Through Back Loop (tbl)

Insert right needle through the loop on the back of the left needle from front to back, wrap the yarn around the needle, and pull a loop through while slipping the stitch off the left needle. This is similar to a regular knit stitch but is worked into the back loop of the stitch instead of the front.

Pick Up and Knit

Along Cast-On or Bind-Off Edge

With right side facing and working from right to left, insert the tip of the needle into the center of the stitch below the cast-on or bind-off edge **(Figure 1)**, wrap yarn around needle, and pull through a loop **(Figure 2)**. Pick up 1 stitch for every existing stitch.

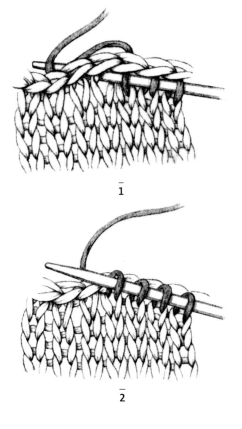

1

2

Along Shaped Edge

With right side facing and working from right to left, insert tip of needle between last and second-to-last stitches, wrap yarn around needle, and pull through a loop. Pick up and knit about 3 stitches for every 4 rows, adjusting as necessary so that picked-up edge lies flat.

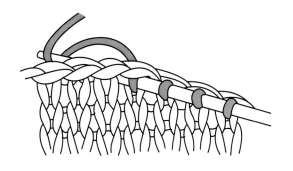

Seaming

Mattress Stitch

Place the pieces to be seamed on a table, right sides facing up. Begin at the lower edge and work upward as follows: Insert threaded needle under one bar between the 2 edge stitches on one piece, then under the corresponding bar plus the bar above it on the other piece **(Figure 1)**. *Pick up the next two bars on the first piece **(Figure 2)**, then the next two bars on the other **(Figure 3)**. Repeat from *, ending by picking up the last bar or pair of bars on the first piece.

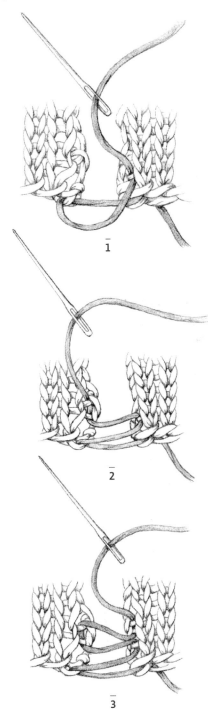

1

2

3

Short-Rows

Knit Side

Work to turning point, slip next stitch purlwise **(Figure 1)**, bring the yarn to the front, then slip the same stitch back to the left needle **(Figure 2)**, turn the work around and bring the yarn in position for the next stitch—1 stitch has been wrapped, and the yarn is correctly positioned to work the next stitch. When you come to a wrapped stitch on a subsequent row, hide the wrap by working it together with the wrapped stitch as follows: Insert right needle tip under the wrap (from the front if wrapped stitch is a knit stitch; from the back if wrapped stitch is a purl stitch; **Figure 3**), then into the stitch on the needle, and work the stitch and its wrap together as a single stitch.

Purl Side

Work to the turning point, slip the next stitch purlwise to the right needle, bring the yarn to the back of the work **(Figure 1)**, return the slipped stitch to the left needle, bring the yarn to the front between the needles **(Figure 2)**, and turn the work so that the knit side is facing—1 stitch has been wrapped, and the yarn is correctly positioned to knit the next stitch. To hide the wrap on a subsequent purl row, work to the wrapped stitch, use the tip of the right needle to pick up the wrap from the back, place it on the left needle **(Figure 3)**, then purl it together with the wrapped stitch.

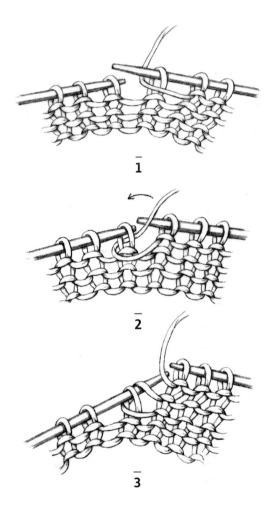

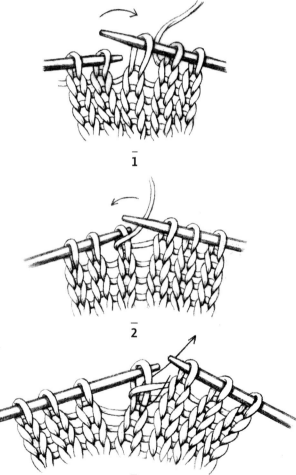

Weave In Loose Ends

Thread the ends onto a tapestry needle and trace the path of a row of stitches **(Figure 1)** or work on the diagonal, catching the back side of the stitches **(Figure 2)**. To reduce bulk, do not weave two ends in the same area. To keep color changes sharp, work the ends into areas of the same color.

1

2

Yarnover (yo)

Yarnover between 2 knit stitches
Wrap the working yarn around the needle from front to back and in position to knit the next stitch.

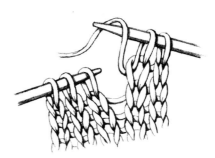

Yarn Sources

Berroco Inc.
1 Tupperware Dr., Ste. 4
N. Smithfield, RI 02896-6815
(401) 769-1212
info@berroco.com

Brooklyn Tweed
brooklyntweed.com
info@brooklyntweed.com

Cascade Yarns
1224 Andover Pk. E.
Tukwila, WA 98188
(800) 548-1048
cascadeyarns.com

Dragonfly Fibers
4104 Howard Ave.
Kensington, MD 20895
(301) 312-6883
dragonflyfibers.com

Fibre Company
Distributed in North America
by Kelbourne Woolens
228 Krams Ave.
Philadelphia, PA 19127
(267) 766-5480
info@kelbournewoolens.com

**Frabjous Fibers/
Wonderland Yarns**
22 Browne Ct.
Unit 165
Brattleboro, VT 05301
(802) 257-4178
info@frabjousfibers.com

Lorna's Laces
4229 N. Honore St.
Chicago, IL 60613
(773) 935-3803
yarn@lornaslaces.net

Malabrigo
(786) 866-6187
Fax: 786 513 0397
malabrigoyarn.com

Manos del Uruguay
Distributed in the U.S.
by Fairmount Fibers LTD.
PO Box 2082
Philadelphia, PA 19103
(888) 566-9970
Fax: (215) 235-3498
info@fairmountfibers.com

Mrs. Crosby
4229 N. Honore St.
Chicago, IL 60613
(872) 230-4713
mrscrosbyplays.com

O-Wool
(888) 673-0260
o-wool.com
info@o-wool.com

Quince & Co.
quinceandco.com
info@quinceandco.com

Spud and Chloë
Blue Sky Alpacas
Attn: Spud & Chloë
PO Box 88
Cedar, MN 55011
(888) 460-8862
info@spudandchloe.com

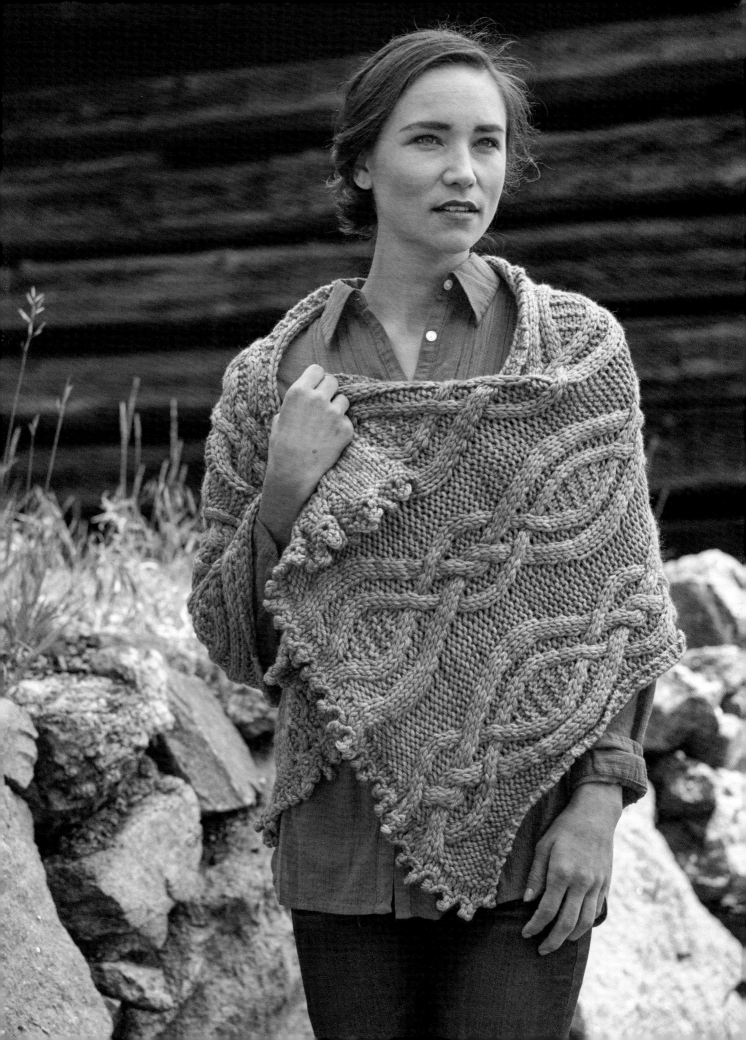

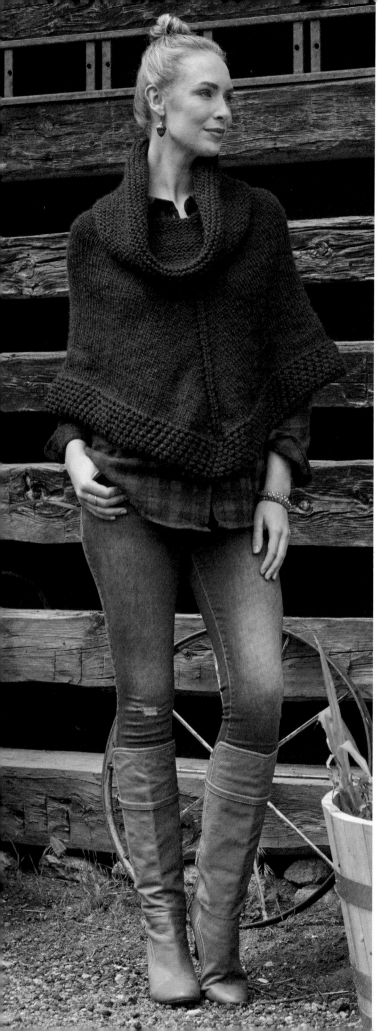

About the Designers

Amy Christoffers is the design director at Berroco Inc. and author of *New American Knits* (Interweave, 2014). She has published more than 150 designs in magazines and in yarn company design collections, as well as on her own website, savoryknitting.com.

After leaving a career in advertising to raise her two daughters, **Thea Colman** found that she liked imagining sweaters more than actually following a pattern and began writing her own. Combining design with a longtime interest in cocktails made for a perfect second career, and BabyCocktails began. Thea lives in the Boston area and has published more than 100 patterns. Almost all of them are named after cocktails, and recipes are often posted on her blog, babycocktails.com.

A graduate of RISD, **Tanis Gray** lives in Alexandria, Virginia, with her husband, son, and lazy pug. She has been working in the creative field for many years, including at Martha Stewart, HBO, Focus Features, and as yarn editor at *Vogue Knitting* and co-editor of *Knit.1*. Tanis is currently working on her eighth knitting book, photographing knitting books for other designers, and sewing project bags for her Etsy shop, tanisknits.

Carrie Bostick Hoge is a knitwear designer and photographer based in Maine. She is the self-published author of the Madder Anthology book series. Carrie's designs have also been published in Brooklyn Tweed's *Wool People*, *New England Knits*, *Fair Isle Style*, *Taproot*, *Interweave Knits*, *Knitscene*, and on the Quince & Co. website. See more of her work at maddermade.com.

Bristol Ivy is a knitting designer and fiber artist from Portland, Maine. Her work focuses on the intersection between classic tailoring and innovative technique, creating a unique and wearable aesthetic while maintaining knitterly appeal. It is inspired by the local Maine landscape and Portland's unique style, Japanese and Scandinavian design, women's fashion in the first half of the twentieth century, and many, many repeat viewings of British period dramas.

Melissa LaBarre is a wool-loving lifelong New Englander. She has been freelance designing since her dear friend Cecily Glowik MacDonald began peer-pressuring her to just write things down in 2008. Since then, her 100+ designs have been published in several books, magazines, and yarn company design collections, as well as on her blog. Along with Cecily, she is coauthor of *New England Knits* (Interweave, 2010), *Weekend Hats* (Interweave, 2011), and Quince & Co.'s Wool Collection series. She works from home while caring for her two young daughters. Visit her website at melissalabarre.com.

Cecily Glowik MacDonald lives, designs, and knits in the wonderful city of Portland, Maine. Along with her many self-published designs, work for magazines and yarn companies, and a self-published book called *Landing,* she coauthored *New England Knits* (Interweave, 2010), *Weekend Hats* (Interweave, 2011), and Quince & Co.'s Wool Collection series with her wonderful, talented friend Melissa LaBarre. See more of her work at cecilyam.wordpress.com.

Kate Gagnon Osborn has been making textiles for as long as she can remember: she sewed and knit with her grandmothers, studied weaving in college, where she obtained a BS and an MS in Textile Design, worked in a yarn shop, founded Kelbourne Woolens with Courtney Kelley in 2008 as the distributors of The Fibre Co. yarns, and never looked back. Her patterns have appeared in *Vogue Knitting, Interweave Knits, Knitscene,* and *Knit/Purl,* as well as the books *Fair Isle Style, Scarf Style Two, Knit Local, New England Knits, Free Spirit Shawls, Weekend Hats,* and in collections under the Kelbourne Woolens brand.

Leila Raabe lives in beautiful Portland, Maine, a place of limitless inspiration all year round. Working and designing for Brooklyn Tweed since 2010, she has also had the pleasure of designing for Quince & Co., Gauge + Tension, and Amirisu. Find out what she's up to these days at her website, leilaknits.com.

Rachel Stecker has been teaching and designing since 2000, starting in Philadelphia, then in her store in Brattleboro, Vermont, Knit or Dye. These days she works as an independent designer, creating patterns for yarn companies and her own line. She lives in southern Vermont with her young son. You can find her patterns and blog at knitordye.net.

Kristen TenDyke is passionate about creating uniquely constructed projects that don't require seaming. She is the author of *Finish-Free Knits* (Interweave, 2012) and *No-Sew Knits* (Interweave, 2014), which are full of seamlessly constructed sweaters. She is the creator of Caterpillar Knits—a line of knit and crochet patterns for eco-conscious crafters—and dedicated to using yarns that continue to sustain our planet. See more of her patterns on her websites, kristentendyke.com and caterpillarknits.com.

Based in southern Maine, **Leah B. Thibault** ("Ms. Cleaver") aims to practice slow craft, with a sense of place, purpose, and care, and she revels in the joy of making. She designs frequently for Quince & Co. yarns, and her work has appeared in *Knitscene* and *Twist Collective.* In addition to knitting, Leah also spins, sews, embroiders, and bakes a delicious pie. You can view all her patterns and read her Chronicles of a Handmade Life at mscleaver.com.

Angela Tong is a designer, teacher, mother, and food lover living in New Jersey. Her knit designs have been published in numerous magazines and books. She enjoys teaching weaving, knitting, and crochet. As a lifelong crafter, she has never met a craft she didn't like.

Jocelyn J. Tunney lives and works in Philadelphia, Pennsylvania. She owns O-Wool, a yarn company focusing on organic fibers and local production. Find Jocelyn and O-Wool at o-wool.com.

Emma Welford is a knitwear designer from western Massachusetts who delights in finding inspiration all over the place. See more of her work at emmawelford.com.

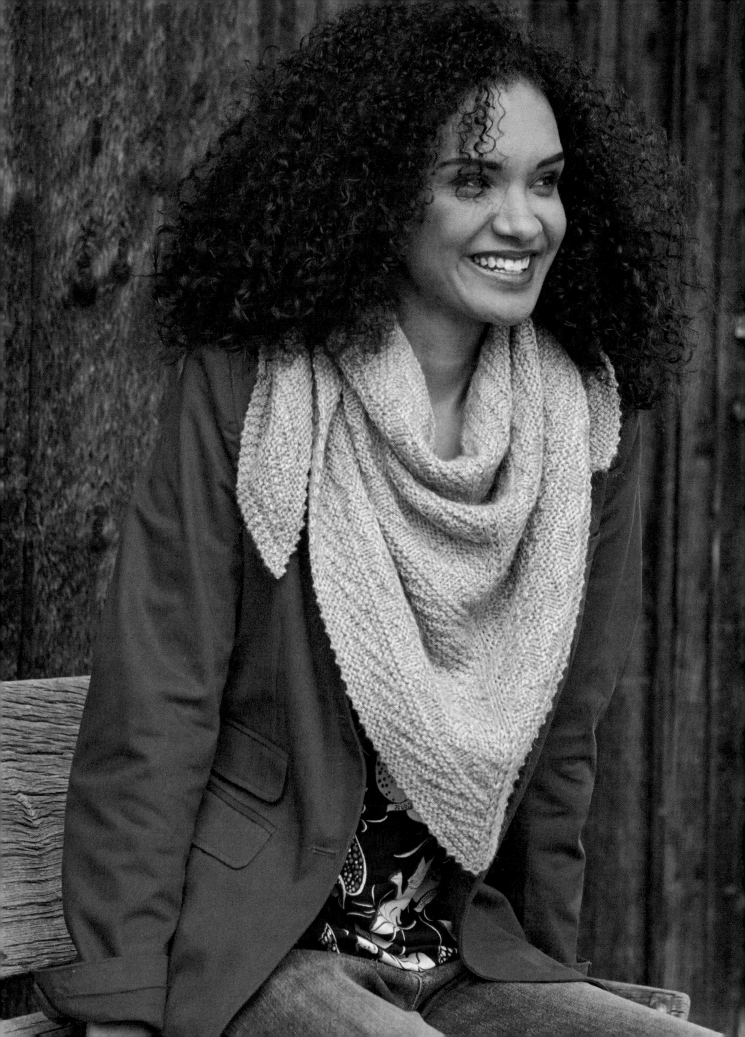

Acknowledgments

We would like to wholeheartedly thank the folks at Interweave, especially Kerry Bogert, for believing in our idea and making this, our third book together, possible. We are so grateful.

To the knitters who have knitted, and continue to knit, our patterns, it is not an understatement to say that we couldn't do this without you. Sometimes it is hard to believe that we get to call this work, but we do, and it is all thanks to you.

Many thanks to the yarn companies who generously donated their beautiful yarn for these projects: Berroco, Brooklyn Tweed, Cascade, Dragonfly Fibers, The Fibre Co./Kelbourne Woolens, Frabjous Fibers, Lorna's Laces, Malabrigo, Manos del Uruguay/Fairmount Fibers, Mrs. Crosby, O-Wool, Quince & Co., and Spud & Chloë. Your lovely wools are often the inspiration behind our designs. We're so happy that you do what you do!

And last but not-at-all-least, we are super grateful for our families and friends, who endured yet another round of "book" talk, another round of too many packages of wool arriving on our doorsteps, and another round of us being even more glued to our laptops. Thanks for pretending that we're not even a little bit boring. We know you all don't really love yarn that much. Thanks for being excited for us anyway!

And you, thanks so much for buying this book. We hope that you'll knit something you truly love.

Happy knitting!

xo Melissa & Cecily

Index

Dedication

For Stella and Viviane, my little loves. You
are the two best reasons for not having
time to knit. —M.L.

fw

a content + ecommerce company

fwcommunity.com

20 19 18 17 16 5 4 3 2

Distributed in Canada by Fraser Direct
100 Armstrong Avenue
Georgetown, ON, Canada L7G 5S4
Tel: (905) 877-4411

Distributed in the U.K. and Europe by F&W MEDIA
INTERNATIONAL
Brunel House, Newton Abbot, Devon, TQ12 4PU,
England
Tel: (+44) 1626 323200, Fax: (+44) 1626 323319
E-mail: enquiries@fwmedia.com

Distributed in Australia by Capricorn Link
P.O. Box 704, S. Windsor NSW, 2756 Australia
Tel: (02) 4560 1600, Fax: (02) 4577 5288
E-mail: books@capricornlink.com.au

SRN: 16KN10
ISBN-13: 978-1-63250-278-0

Editor: Michelle Bredeson
Technical Editor: Therese Chynoweth
Art Director: Elisabeth Lariviere
Cover Designer: Kerry Jackson
Interior Designer: Courtney Kyle
Illustrator: Kathie Kelleher
Photographer: Donald Scott
Stylist: Katie Himmelberg
Hair/Makeup: Kathy MacKay

We make every effort to ensure the accuracy of
our patterns, but errors sometimes occur. See
knittingdaily.com/errata for corrections.

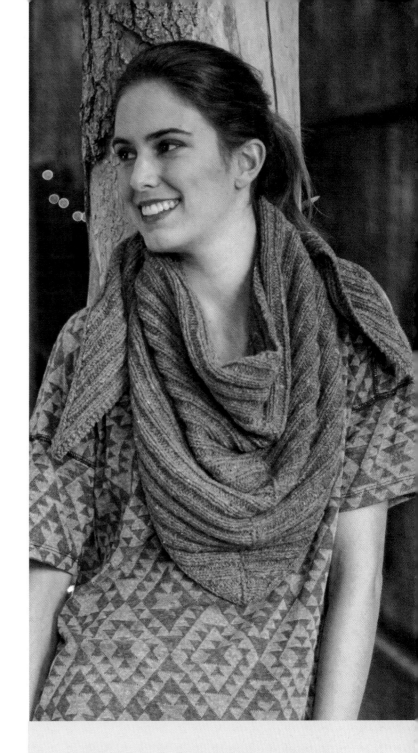

Metric Conversion Chart

To convert:	to:	multiply by:
Inches	Centimeters	2.54
Centimeters	Inches	0.4
Feet	Centimeters	30.5
Centimeters	Feet	0.03
Yards	Meters	0.9
Meters	Yards	1.1

More *Quick* Knits for *Easy* Style

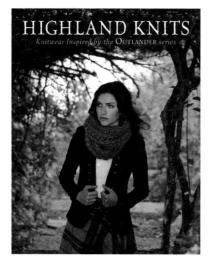

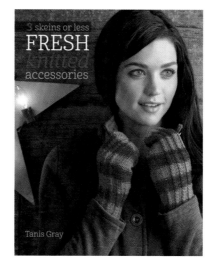

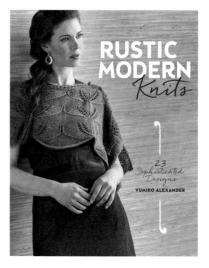

HIGHLAND KNITS

Knitwear Inspired by the
Outlander Series

ISBN 978-1-63250-459-3, $22.99

**3 SKEINS OR LESS: FRESH
KNITTED ACCESSORIES**

By Tanis Gray

ISBN 978-1-62033-673-1, $24.99

RUSTIC MODERN KNITS

23 Sophisticated Designs

By Yumiko Alexander

ISBN 978-1-62033-630-4, $24.99

Available at your favorite retailer or shop.knittingdaily.com